A–Z

OF

YEOVIL

PLACES – PEOPLE – HISTORY

Bob Osborn

AMBERLEY

For Carolyn and Alice

First published 2018

Amberley Publishing
The Hill, Stroud, Gloucestershire, GL5 4EP
www.amberley-books.com

Copyright © Bob Osborn, 2018

The right of Bob Osborn to be identified as
the Author of this work has been asserted in
accordance with the Copyrights, Designs and
Patents Act 1988.

ISBN 978 1 4456 7506 0 (print)
ISBN 978 1 4456 7507 7 (ebook)

British Library Cataloguing in Publication Data.
A catalogue record for this book is available
from the British Library.

Origination by Amberley Publishing.
Printed in Great Britain.

Contents

Introduction

This book will take you on a tour of Yeovil's past and present in alphabetical order. Using a mix of old and new photographs, it features the stories behind some of the most notable streets and buildings, the sources of a few of the more unusual place names and the history of many of its distinctive features, as well as telling tales of the town's history. I have also included a few of Yeovil's famous sons and daughters, the places they frequented, as well as several of the town's buildings, both old and modern. I have even included some old unauthorised coins made and used in Yeovil.

The town may no longer be the thriving hub of glove manufacturing it once was, but by examining its history a little deeper, you will find an exciting story dating back centuries. From its early Roman connections to its expansion as a major centre of glove making in the 1800s and later growth of its aircraft and defence industries, the town has always played an important role in the local area and county.

Based around many of the items featured in my 2,100-plus-page website, the A to Z of Yeovil's History (www.yeovilhistory.info), I hope this companion volume will appeal to residents and visitors alike.

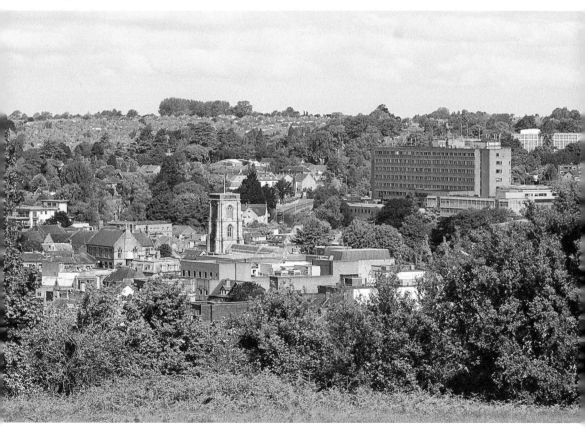

The view from Summerhouse Hill, with St John's Church tower at centre.

Alexandra Hotel

Although the railway came to Yeovil in 1853 (the first station being at Hendford), Yeovil Town station was the last of Yeovil's four railway stations to be built, opening in 1861 (finally closing in 1961). Very shortly thereafter and in its prime location, the Alexandra Hotel, together with the rest of South Western Terrace, was built by Levi Ridout to accommodate railway travellers. A large, imposing building on a corner site, it was built to directly face the station and impress travellers – for many it would be their first impression of Yeovil as they stepped off their train.

An advertisement in Whitby's *Yeovil Almanack Advertiser* of 1896 states 'Waggonettes, Dog Carts, Open & Close Carriages, Stabling and Loose Boxes for Hunters. Saddle Horses and Hunters for Hire.' In the same advertisement is the statement 'Nearest House to the Joint Stations', a reference to the fact that two railway companies used the Yeovil Town station and each had their own stationmaster.

The new hotel was named, in a flurry of patriotism, after the popular Princess Alexandra of Denmark (1844–1925), who became the consort of Edward VII when they married in March 1863, shortly before the hotel opened. By 2015 it had become a hotel, Terrace Lodge.

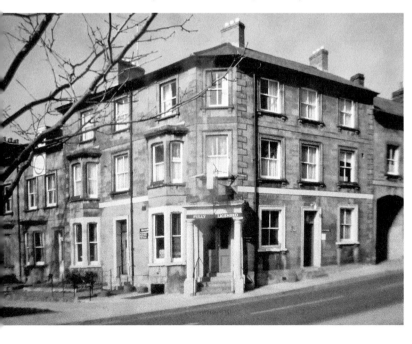

The Alexandra Hotel, photographed in the 1980s.

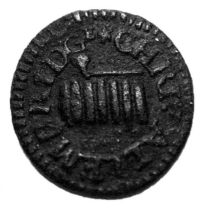

A trade token issued by Christopher Allembridge in 1656 featuring a pipe and roll of tobacco.

Allembridge, Christopher

There were at least three, possibly four, successive generations of Yeovilians called Christopher Allembridge. The first Christopher Allembridge we know of was a mercer and tobacconist. A document dated 1634 recorded him as a 'Tobacconist of Evill' – an early spelling of Yeovil. He was also a warden of Woborn's Almshouse in 1631. This same year he was recorded in a lease for a Yeovil inn called the Black Cock. He was also mentioned by name in the letters patent of Charles I requesting a charitable collection from the nation in response to the Great Fire of Yeovil of 1640.

His dwelling house was 'called by the name of ye sign ye Beare', so it would seem that Christopher was also one of Yeovil's landlords, or at least owner, of early alehouses. It was described as being 'in ye Burrough of Yeavel'. His will also refers to 'his shopp', but whether this was integral with the Bear or separate premises is not clear.

Christopher the Elder died in 1645, succeeded by his son, Christopher the Younger, who ran the 'shopp' and was described as a grocer in a deed of 1659. Judging from a trade token sporting the image of a pipe and a roll of tobacco dated '1656' he was a tobacconist like his father. By 1694 Christopher Allembridge the Younger was dead and the Bear Inn passed to his son, also Christopher Allembridge.

Aplin & Barrett

In 1888, James Shorland Aplin and William Henry Barrett merged their wholesale dairy businesses together for the purpose of creating and marketing cheese, cream and butter. In 1891, the Western Counties Creamery moved to Marston Magna from Rimpton and in 1898 it was amalgamated with Aplin & Barrett Ltd.

Around the turn of the century, Aplin & Barrett acquired some 2 acres of land on the eastern side of Newton Road, near its junction with Middle Street, that had been the extensive grounds of Osborne House. The decision to purchase was undoubtedly enticed by the close proximity of Yeovil Town railway station and its associated goods yard at the heart of a potential national distribution system for their products.

The St Ivel brand was born in 1901 and applied to a range of their products, even though there is no saint of that name. In fact, Ivel was one of the spellings accorded to Yeovil by John Leland in his Itineraries of 1533–46. Nevertheless, the brand became

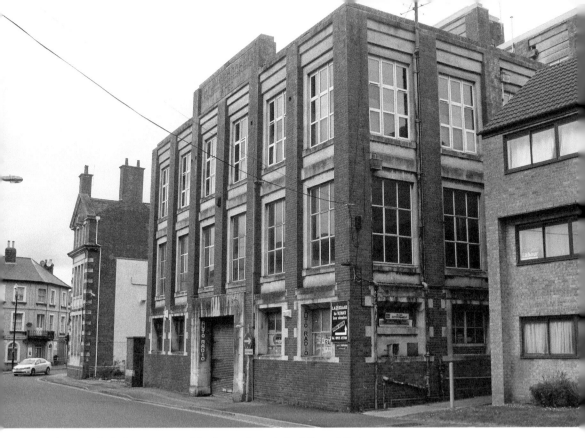

At centre is the last remnant of the former large Aplin & Barrett factory.

well established, nationally famous and included butter, creams and cheeses. Their famous 'St Ivel Lactic Cheese' was introduced in 1909. Aplin & Barrett also produced a limited range of meat products such as pork pies, sausages and potted pastes.

In 1957, Aplin & Barrett produced the first commercial extract of nisin, an antibacterial peptide used during the manufacture of processed cheese, meats, beverages and so forth in order to extend the product's shelf life. In 1960, the company was acquired by the Unigate Group, who closed the Yeovil premises in 1976, transferring many of their staff to other branches, particularly Westbury, Wiltshire. The St Ivel brand, however, continued long after the closure of Aplin & Barrett.

Armorial Achievement

This achievement of arms was granted in 1954 to mark the centenary of Yeovil's incorporation as a municipal borough and regranted in 1985 following the town achieving parish status.

The main shield depicts St John the Baptist as shown on a fourteenth-century town seal. The croziers represent the bishopric of Bath and Wells and the abbey and convent of Syon, whose abbess was town lord in the fifteenth and sixteenth centuries.

The crowns above them are for Empress Matilda, who placed the eleventh-century 'Tenement' of Yeovil under the protection of the parish church of Saint John, and for King John, who granted Yeovil a fairs and markets charter in 1205. The Saxon crown, on a civic helm, recalls King Alfred the Great, owner of Kingston Manor,

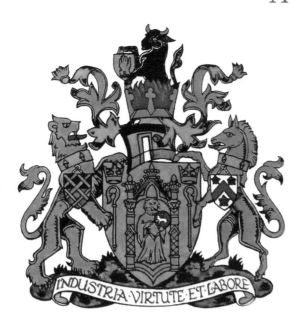

The armorial achievement granted to Yeovil.

while the flames represent the devastating medieval fires. The bull represents the agricultural and dairy industries – a reminder of the nature of the livestock markets that contributed largely to the town's growth. The small shield bearing a golden glove is symbolic of Yeovil's former staple industry.

The supporters are from the arms of former manorial lords. The golden lion is from the earls of Arundel, to whom the manor of Hendford was passed from the Maltravers family. The golden horse derives from the Horseys of Clifton Maybank, who had the lordship of the manor of Yeovil at the time of the Dissolution of the Monasteries, when the convent of Syon was disbanded.

The shield borne by the lion displays the arms of Maltravers (black fretted with gold) and Whitemore (green fretted with gold) who held the lordship for a year under James I. The shield borne by the horse displays the arms of Phelips of Montacute, who took over the lordship from the Whitemore family. The blue collars with gold arrowheads are elements from the arms of Harbin of Newton Surmaville.

The motto, *Industria Virtute et Labore*, translates as 'By Diligence, Courage and Work', the initials of the Latin rendering spelling an early form of the town's name – IVEL.

Assembly Rooms

The grand building in Princes Street that was home to the Princes Street Constitutional Club, the Assembly Rooms, was built in 1888 and opened the following year. The large Assembly Room itself, measuring 40 feet (12.2 metres) across by 65 feet (19.8 metres) deep, could accommodate a thousand people. Additionally, there was a billiards room, a cards room and a reading room for members' use.

In 1895, a permanent stage was built, complete with a proscenium arch and three dressing rooms, reducing the overall capacity of the venue to around 700. The Assembly Rooms was the first place in Yeovil to show films – black and white

The former grand Assembly Rooms have now been converted to shops and offices.

one-reelers – from 1896 when Yeovil's first film licence was granted. This was also the year that the very first public screening of a film in England took place in London.

As well as showing films, the Assembly Rooms were also hired out for private functions and other theatrical productions. The Yeovil & District Amateur Operatic Society, formed in 1902, put on their annual performances in January or February for many years at the Assembly Rooms. Their final production at the Assembly Rooms, before moving to the newly built Johnson Hall (now the Octagon Theatre) was Rogers & Hammerstein's *South Pacific* in February 1972.

The Assembly Rooms have since been converted, now housing shops on the ground floor and offices above.

Auxiliary Fire Service Buildings

In 1938, the government prepared for what appeared to be inevitable conflict, which would almost certainly involve the use of bombing from the air. Consequently, each fire authority was required to form an Auxiliary Fire Service (AFS). This would come under the direction of the local chief fire officer, whose role was to prepare for the eventuality of war and for dealing with fires that would follow an air raid. Members of the AFS were unpaid part-time volunteers, but they could be called up for whole-time paid service if necessary. This was very similar to the wartime Police Special Constabulary. Two wartime AFS buildings survive in Yeovil, an 'alternative fire station' and an AFS garage.

The alternative fire station, in Mudford Road close to the bend by Hundred Stone, is of brick construction with a tiled roof and additional post-war extensions at both ends. On the northern side of the building there are a number of wooden sliding doors, which appear to be the original entrance to the building. In front of the building a large 11,500-gallon water tank (now removed) provided an emergency water supply, in case bombing destroyed the water mains.

In Goldcroft there is a surviving AFS garage, consisting of a corrugated asbestos roof of the 'Handcraft' type on dwarf brick walls with a large entrance in a brickwork end wall. The original entrance door has been replaced.

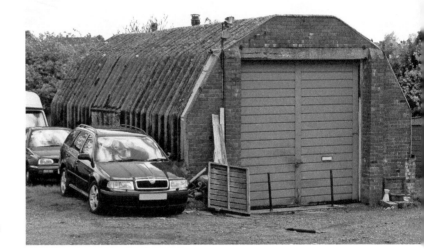

Right: Yeovil's only surviving wartime Auxiliary Fire Service garage.

Below: The former Auxiliary Fire Service's alternative fire station.

B

The Bandstand

Sidney Gardens, a 3-acre triangle of open space in Ram Park, was presented to the town by Alderman Sidney Watts (when he was mayor) to commemorate the 1897 Diamond Jubilee of Queen Victoria. As part of the celebrations, local ironmonger James Bazeley Petter presented the bandstand to the town. Park benches were installed either side of the bandstand so that the public could enjoy musical performances. Trees were planted among the benches and provided shade for those using them. The bandstand was built of wood, with all the rustic work being cut from laurel that grew at Ninesprings. Local bands gave frequent public performances, such as the Yeovil Volunteer Band. Also known as the Yeovil Military Band, this was officially the band of Yeovil F Company, 2nd Battalion, Prince Albert's Somerset Light Infantry. They were stationed at their armoury in Park Road – now the Armoury Inn. The bandstand was vandalised and burnt down in early 1973, never to be replaced.

A hand-coloured 1905 postcard of the Sidney Gardens' bandstand in its heyday.

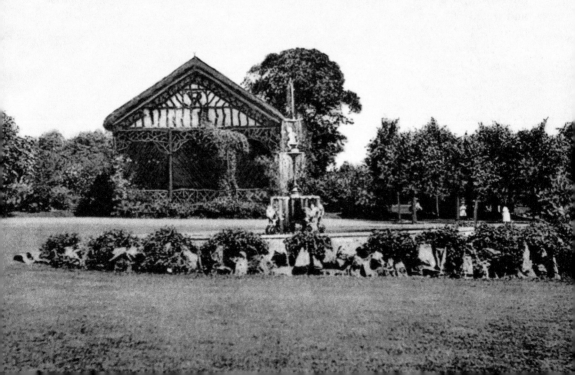

Bide's Gardens is fondly remembered and sadly missed by many older Yeovilians.

Bide's Gardens

Bide's Gardens were donated to the town by Thomas William Dampier-Bide (1844–1916), the son of glove manufacturer Thomas Dampier (1801–76). Upon his death in 1916 he bequeathed to the town a large part of the grounds of Kingston Manor House (where he lived) – lying between Higher Kingston, Court Ash, Court Ash Terrace, Kingston and Red Lion Lane, known thereafter as Bide's Gardens. Many older Yeovilians will remember the gun mounted on a low stone plinth in Bide's Gardens. This was a captured First World War German howitzer given to the borough council by the War Office Trophies Committee and originally sited on a concrete plinth in the Triangle. It was initially proposed that a captured German tank be presented to the town, but the borough council declined the offer when they heard that the tank was 30 feet long, 13 feet wide, weighing some 26 tons and would require a massive concrete foundation that would have to be funded by the council. The howitzer was moved to Bide's Gardens in 1922, where it remained until it was taken away after the Second World War. Yeovil lost Bide's Gardens in the 1970s with the building of the Yeovil District Hospital and the widening of Reckleford.

Blake & Fox

Blake & Fox were leather dressers and glove manufacturers throughout the first half of the twentieth century with a large factory and dressing yard in Summerhouse Terrace. The factory, at the foot of Summerhouse Hill, was built on the site of old allotments around 1905. As a member of the Yeovil & District Glove Manufacturers' Association, the company exhibited in the Glove Exhibit stand of the 1924 British Empire Exhibition at Wembley, London. They were listed as 'Glove Manufacturers of Mill Lane' in Kelly's Directory of 1919 and in Kelly's 1935 edition as 'Glove Manufacturers of Summerhouse Terrace'. There were two entries in Edwin Snell's Directory of 1954: one as 'Leather Dressers' and the other as 'Glove Manufacturers of Summerhouse Road [sic]'. Despite this, there is hardly any further information in the company records. Blake & Fox closed in the late 1960s, following which the factory buildings had a few alternative uses and mainly lay empty for many years. It was finally demolished around 2000.

The large Blake & Fox glove factory at the foot of Summerhouse Hill.

Britannia Inn

The Britannia Inn, Vicarage Street, was originally a fine seventeenth-century two-storey brick house with stone and ashlar to the front elevation and a projecting double-storey bay. It served as a public house from 1861 (after the closure of the Britannia Inn in Belmont) until the 1960s.

The Britannia Inn was initially run by William Gaylard from the early 1860s and he is mentioned in the minutes of the Volunteer Fire Brigade following a fire at the Britannia in 1865. A further fire in 1880 completely destroyed the Britannia Inn, although it was rebuilt later. The minutes of the Volunteer Fire Brigade, following the August 1880 fire, elected to charge Mr J. Brutton for attending the fire. Joseph Brutton was the owner of Brutton's Yeovil Brewery and this entry clearly indicates that the Britannia Inn was a tied house that belonged to the brewer.

In 1969, this version of the Britannia Inn was demolished – brick by brick – and the materials were used to build a private house at Ash.

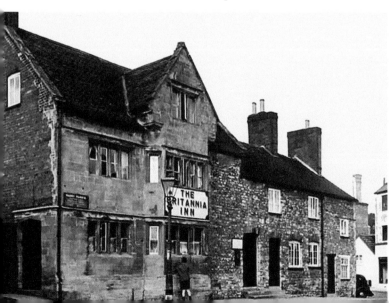

Vicarage Street's Britannia Inn was demolished and rebuilt at Ash in 1969.

Brutton's Brewery

Joseph Brutton was born on 25 May 1831 in Exeter, Devon. His father, also Joseph, was in the licensed trade and owned several pubs in Exeter. By 1851 his father had died and Joseph, aged nineteen, described himself as a brewer.

By 1854 Joseph Brutton had moved to Yeovil and entered into a brewing business with Thomas Cave; from that date the business was known as Cave & Brutton. Thomas Cave died on 10 September 1863 and Joseph Brutton carried on the business on his own, giving his occupation as 'Common Brewer, Wine and Spirit Merchant, Master, employing 20 men' in the 1871 census. Brutton's new malthouse was one of the first pneumatic malting houses in the country and was built by 1885.

Joseph Brutton retired due to ill health in 1893 and moved to Eastbourne, Sussex. He died there in 1914 aged eighty-two. After his retirement his sons carried on the business and significant improvements to the brewery were recorded in 1893. The business was listed as 'Brutton & Sons Ltd, Wine and Spirits Merchants of Princes Street' in Collins' Yeovil Directory of 1907 and as 'Joseph Brutton & Sons Ltd, Wine and Spirits Merchants of Princes Street' in Kelly's Directory of 1935.

Mitchell, Toms & Co. Ltd of Chard became associated with Joseph Brutton & Sons Ltd around 1935 and took over Brutton's in 1937, with the company renamed Brutton, Mitchell & Toms Ltd. The Chard brewery closed in June 1937 and all brewing was concentrated in Yeovil. The company acquired Dorsetshire Brewery (Sherborne) Ltd of Long Street, Sherborne, in 1951 along with seventy-eight licensed houses and three off-licenses. From this date the Dorsetshire Brewery ceased to brew.

The business was taken over by Charrington & Co. Ltd, London, in 1960 and changed its name to Charrington & Co. (South West) Ltd in 1963. The Yeovil Brewery ceased to brew in 1965. The site of the malthouse is now covered by Tesco car park. The brewery site was redeveloped for housing in 2004.

Brutton's yard around 1900, complete with horse-drawn and steam-powered drays.

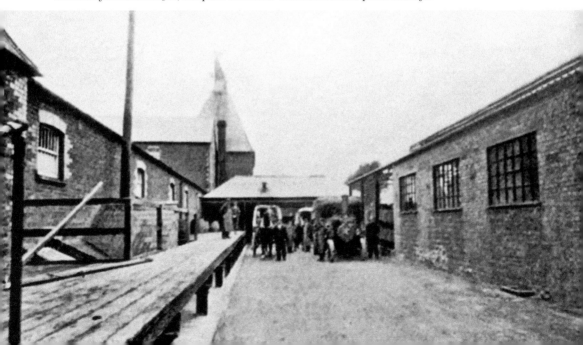

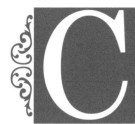

Castle Inn

Before its demolition in 1927 for street widening, the Castle Inn was Yeovil's earliest house. It was, in part, thirteenth century and had been an old medieval chantry property. A chantry was a fund to pay for a priest to celebrate daily Masses, generally for the benefit of the soul of the deceased donor. It was one of seven chantry properties surviving the Great Fire of Yeovil of 1449.

When it first opened as licensed premises, probably before 1668, it was called the Hart or the White Hart. Later it was known as the Higher, or Upper, Three Cups, until around 1750 to distinguish it from another old medieval pub in Middle Street called the Three Cups, itself later renamed as the George.

Although it was one of Yeovil's four coaching inns, it is unlikely that a coach and horses would be driven through the small central arch since the road at this point was just 12 feet wide and there wasn't enough space in the Castle's rear yard to turn a coach – the stables and coach house were almost certainly off-site.

During the early 1920s it was reported that the building was to be demolished and the site to be used for an 'Up-to-Date Picture House'. In fact, this did not materialise and the historic building was finally demolished in 1927, against much public outcry, to be replaced by shops.

A hand-coloured postcard of the Castle Inn, part of which was thirteenth-century.

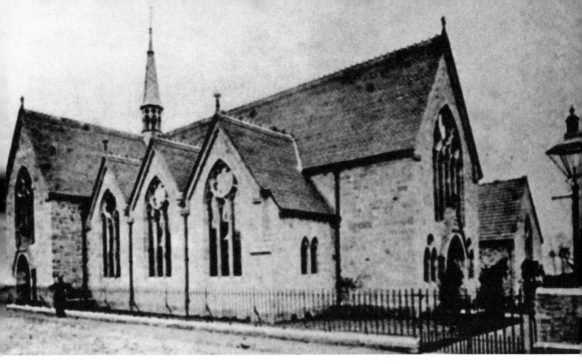

Christ Church, photographed around 1880, would only survive for twenty-five years.

Christ Church

The Reformed Episcopalian Christ Church, together with a Sunday school building to its rear, was constructed in the newly built Park Road (this part, to the west of modern Queensway, is now called The Park) and completed in 1880 at a total project cost of around £3,600 (roughly £1.5 million at today's value). The land that it was built on had been the extreme eastern tip of the wedge-shaped Ram Park.

It was built in the Early English Revival style with a nave and chancel and boasted a polygonal apse and a spirelet. It was designed to seat a congregation of 500.

Henry Stiby, ironmonger, amateur photographer and later Mayor of Yeovil, served for several years as superintendent of Christ Church Sunday School and was known as 'The Children's Friend'.

Unfortunately, the congregation of Christ Church dwindled dramatically and in 1904 the church fabric, together with the Sunday school building, was demolished. The church had lasted just twenty-five years. The stone, wood and other materials were used to construct a short terrace of houses on the site – Christchurch Villas. Christchurch Villas were themselves demolished for the construction of Queensway in the 1980s. The site of Christ Church and the subsequent Christchurch Villas is now the western end of the Park Road / The Park pedestrian bridge over Queensway.

Civic Centre Project

The Town Hall in High Street, which had been built in 1849, was destroyed by fire in 1935. Municipal offices had been constructed along the western side of the new King George Street and opened in 1928. However, the council decided that a new civic centre was called for. The year following the fire – 1936 – the council purchased Hendford Manor and its extensive grounds with the intention of using the site for the proposed new civic complex.

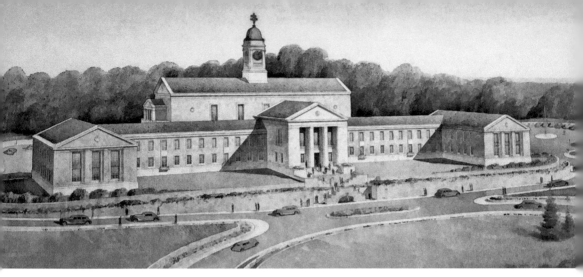

This impressive building was a submission for the 1938 Civic Centre competition.

A competition was held to design a new civic centre complex with a prize of £200 (around £50,000 at today's value) for the winning design. The winning design was by Mr R. Cecil Howitt FRIBA of Mansfield, Nottinghamshire.

The new civic centre, to be built in stone-coloured brick with sandstone dressings, would contain a new town hall, municipal offices, a public library and a museum. The town hall would include a large hall with seating for around 1,000 people, complete with a stage and dressing rooms. A smaller hall for around 250 would also be included, as would a reception room, foyers and catering facilities. The new municipal offices would house the council chamber with a fifty-person viewing gallery, committee rooms, the mayor's parlour as well as a host of other smaller rooms. It would also accommodate a lending library of 20,000 books, a reference library and reading rooms. A museum and storerooms were also included in the design.

The Yeovil Law Courts in Petters Way was first of the new municipal buildings to be constructed and this opened in 1938 (albeit not part of the original competition-winning scheme). The start of the Second World War the following year brought an abrupt and final halt to the civic centre project. It wasn't until the construction of Maltravers House in 1969, to house county council and government departments, that any further building work was carried out on the site.

Colmer, Dr Ptolemy

Ptolemy Samuel Henry Colmer was born in South Petherton in 1841. He was the son of herbalist Robert Slade Colmer and his wife, Jane (née Allen), who were both later to be found guilty of murder. Ptolemy's father was a medical herbalist and in 1851 was living in Middle Street with his wife and five young children. In the 1861 census Ptolemy was listed as a boarder at No. 94 Dundas Street, Glasgow, where he was a medical student.

On 24 February 1865 in the parish church of St Giles Cripplegate, London, Ptolemy married Susan Jacob, the daughter of Baltonsborough farmer Robert Jacob. On his marriage certificate Ptolemy listed his profession as 'physician & surgeon' and his residence as 'St Giles Cripplegate'. Susan died in the winter of 1870 and the 1871 census shows Ptolemy listed as a twenty-nine-year-old physician and surgeon

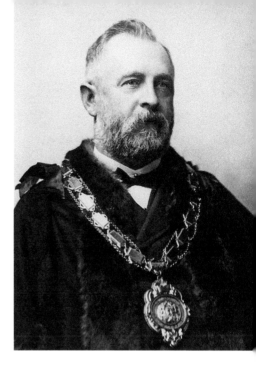

Doctor Ptolemy Colmer's mayoral portrait of 1890.

living in Princes Street, Yeovil, with his three children, all aged under five: Ptolemy Augustus, Frances Gertrude and Albert Ernest.

In the summer of 1871 Ptolemy married his late wife's sister, Frances Louisa Jacob. Ptolemy and Frances had two children: Ralph Henry James, born in 1874, and Arnold Hugh, born in 1878. Unfortunately, Frances died shortly thereafter.

On 15 April 1880 Ptolemy married for the third time at Wood Green in north London. He was now aged thirty-eight and a widower. His new wife was twenty-two-year-old spinster Catherine Mary Offin of Wood Green. The 1881 census listed Ptolemy and Catherine at South Street House, Yeovil, with six children, Ptolemy's sister Bernice and his assistant Robert Gilbert, together with a housemaid, a cook and a nurse. Ptolemy and Catherine were to have two children: Cecil, born in 1881, and Vyvian, born in 1882.

Ptolemy entered local politics and was elected Mayor of Yeovil twice, serving from 1887 to 1889 and again from 1890 to 1892. He remained on the council as an alderman after his service as mayor. In 1892 he was appointed as a borough magistrate. In 1892, he retired from public office and died in Yeovil in 1897.

Coronation Hotel & Vaults

The Coronation Hotel & Vaults was an impressive but relatively short-lived establishment in Middle Street, on the north side of the Triangle. It was built *c.* 1900 on the site of the old Blue Ball Inn. The Coronation Hotel & Vaults, owned by Mitchell, Toms & Co., opened on Thursday 17 July 1902.

The Coronation Hotel & Vaults was a large three-storey building in brick with stone string courses, quoins and mullioned windows under a tiled roof that sported a wooden lantern with a cupola. There was a decorative stone frieze just below eaves level, reaching down to the midpoint of the second-floor windows. The ground-floor windows were set back behind an attractive four-arch colonnade on

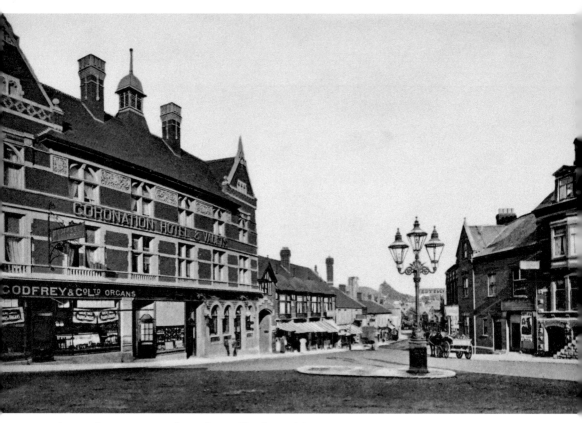

The grand Coronation Hotel & Vaults would only stand for some fifty years.

Corinthian columns. On the ground floor just under half the frontage was occupied by a retail outlet, initially Godfrey & Co.'s piano shop, followed by Smart's furniture store.

During the 1920s advertisements in Whitby's *Yeovil Almanack Advertiser* frequently offered a dozen pint bottles of 'nourishing' stout for 2*s* 6*d* – that's around 10p a pint at today's value. The hotel boasted a billiard room and, unusually for fairly modern town centre pubs and hotels, it also had a skittle alley.

The Coronation Hotel & Vaults was finally demolished around 1965 as part of the Glovers Walk shopping complex redevelopment. It had served Yeovil for only some fifty years before succumbing to the 'progress' of 1960s concrete and steel architecture – an unfortunate demise for such a grand building that was surely the most architecturally impressive of Yeovil's watering holes.

D

Deposit Bank

The beginnings of the Deposit Bank in High Street were outlined by Daniel Vickery in 1856:

> A safe depository for the poor man's savings was long the object of public solicitude; and at last, the Government taking the matter in hand, brought a bill, or bills, before Parliament, which established, under very strict regulations, what are now called Savings Banks, all over the country. This kind of bank was first established in Yeovil on 11 March 1818, Mr Boucher, bookseller, being appointed the first Actuary. Mr Porter, the bookseller, afterwards became Actuary, who removed his shop and the bank to the premises now occupied by Mr Custard, bookseller. On Mr Porter's removal, Mr Custard was appointed to the office. Previous to this, the trustees, in the year 1838, erected the present handsome building, on premises then occupied by Mr Hull, glover, at a cost of about £1,000.

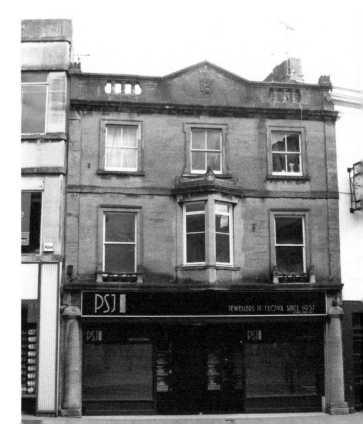

The former Deposit Bank with its 'DB' logo at a high level and its Doric columns.

Wealthy glove manufacturer George Mayo played a large part in founding the first Yeovil Savings Bank and was its chairman in 1839 when its new premises were opened in High Street. The building was designed by Bennett and built by Churchouse – both Yeovil men. At the time of the opening the *Western Flying Post* reported: 'A handsome building, three storeys high, mostly in the Grecian style, with balcony, portico and balustrade.'

Today the ground floor has been converted to shop premises but still retains the fluted Doric columns at ground-floor level and the intertwined 'DB' monogram (for Deposit Bank) survives in the pediment of the parapet.

Donkey (Gloving)

The gloving 'donkey', an item of equipment that revolutionised the gloving industry, was invented in 1807 by James Winter of Stoke-sub-Hamdon. It is not known if James made any money out of his invention, as records for him are somewhat scarce. However, in the 1841 census seventy-five-year old James was recorded as living on 'independent means' with his wife and two servants at Stoke-sub-Hamdon. James was also listed in the 1846 poll book for Stoke-sub-Hamdon by virtue of owning a freehold house and land.

Winter's invention consisted of a clamp mounted on a wooden pedestal. The clamp was spring-mounted and operated by a foot pedal. Along the edge of both sides of the clamp were strips of brass with evenly spaced teeth. The device held the glove firmly but enabled the glove sewer to produce accurate stitching by using the brass teeth as a guide for the needle. At this time, of course, all gloves were stitched by hand and the even and accurate stitching the donkey enabled was an important step in glove manufacturing.

During the nineteenth century all the glove manufacturers employed outworkers, invariably women and girls who worked at home sewing gloves. The gloving donkey enabled more speedy glove production, even enabling girls as young as eight years of age to produce work of an acceptable standard. The gloving donkey was in constant use until the gradual introduction of the sewing machine in the 1880s.

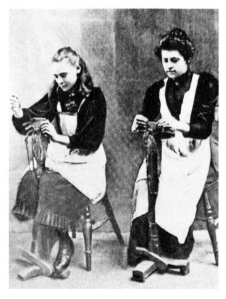

The gloving 'donkey' allowed girls as young as eight to neatly stitch gloves.

E

Elizabethan Beacons

Beacons were fires lit at well-known locations on hills or high places for signalling over land that enemy troops were approaching in order to alert defences. The most famous examples are the beacons used in Elizabethan England to warn of the approaching Spanish Armada. Many hills in England were named Beacon Hill after such beacons.

The spelling is also found as 'Bicken' and 'Bicking' and the 1743 *Terrier* notes: 'Mr Forbes' Bicken, six acres,' while Edward Watts' map of 1806 shows Milford Lane (part of today's Goldcroft) leading 'To Bicking'. Yeovil had two Elizabethan beacons: the first, off Mudford Road, is the highest point in Yeovil and most suitable for such a signal fire. Directly opposite the Hundred Stone, the location was recalled in the field name of the signal fire as Beacon. The 1589 *Terrier* noted that the beacon was in the great Middle Field of Kingston Manor. The 1846 Tithe Award listed fields called Lower Beacon, Higher Beacon, Beacon, Beacon Ground and Beaconfield, indicating that the former large field had been subsequently divided.

On the other side of Yeovil a further signal fire was located on another high spot off West Coker Road, commemorated with Beaconfield Road – not to be confused with Beaconsfield (with an 's' in the middle) – and Terrace in St Michael's Avenue, which was named after Benjamin Disraeli, prime minister in 1863 and 1874–80 and created Earl of Beaconsfield in 1876.

In more recent times, such as for Queen Victoria's various jubilees and the coronations of Edward VII and George V, the signal beacon bonfires were built on Summerhouse Hill.

Evacuees

At the beginning of the Second World War the evacuation of Britain's cities was the biggest and most concentrated mass movement of people in Britain's history. It was expected that cities would be bombed, as the enemy tried to destroy factories. It was realised that homes and schools would also be in danger. The government tried at the start of the war to 'empty the cities' of children and mothers, the process of 'evacuation', to protect them from air raids. In the first four days of September 1939, nearly 3 million people were transported from towns and cities in danger from enemy bombers to places of safety in the countryside. Most were schoolchildren, who had been labelled like pieces of luggage, separated from their parents and accompanied instead by a small army of guardians – 100,000 teachers. It was an astonishing

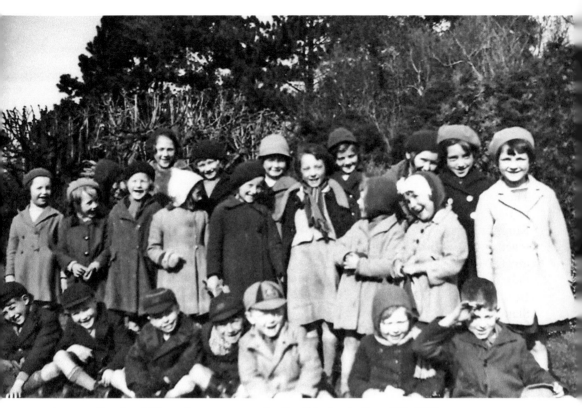

A group of London children who were evacuated to Yeovil during the Second World War.

event by any measure, a logistical nightmare of coordination and control. The mass evacuation began on Thursday 31 August 1939, but very few realised that within a week a quarter of the population of Britain would have a new address.

It was planned that Yeovil would receive 4,410 evacuees from London, made up of 2,207 unaccompanied children and 2,207 teachers, helpers and others, including mothers with children under school age. How would they cope? Where would everybody stay? Who would feed them? The problems initially seemed insurmountable, but with careful planning and forethought Yeovil came up with a plan. This scheme was so thorough and so complex that it was produced as a nineteen-page booklet with tables at the end, showing who was to stay where.

Nevertheless, in practice this careful planning has been called into question. One young London lad who was evacuated to Yeovil later recalled: 'There seemed to be no plan as to where we were to stay and I can remember walking the streets of Yeovil in the dark with grown-ups knocking at doors asking people if they would take an evacuee.'

F

Far End House

Thomas Moore began working as a solicitor in West Coker but before 1839 had moved to Yeovil. He had his legal practice at Far End House, Back Kingston (today's Higher Kingston); his family lived here too. They were listed there in the 1841 census and together with Thomas and his wife Elizabeth were their four children, an articled clerk and two female servants. In 1840, the Somerset Gazette Directory listed Thomas twice: once as an attorney of Back Kingston and also as the agent for the Atlas Fire & Life Insurance Company. Both listings were repeated in Hunt & Co.'s Directory of 1850 and Slater's Directory of 1852. Thomas Moore died in the winter of 1859, aged sixty-eight.

Thomas Moore's home, 'Far End House', was designed to create a grand first impression. Its sweeping driveway and extensive gardens were reached from Kingston, some distance away. The overall impression, when seen from Kingston, was of a gentleman's country house set in a large landscaped garden. The less-impressive rear elevation of the house backed immediately onto Higher Kingston.

By 1961 Far End House was owned by the Ministry of Health. It was demolished during the late 1960s to make way for the new district hospital and its site is now the hospital's front drop-off point.

The approach to Far End House was impressive, although its rear was directly on the road.

Fernleigh Commercial Temperance Hotel

The London Commercial Temperance Hotel was built on the corner of Middle Street and Station Road in the mid-1860s. In 1868, the first mention of a hotel at this location was in a court case referring to 'Mrs Mercy Hebditch of the London Temperance Hotel, Townsend'. In an advertisement of 1882, the hotel was described as having 'coffee, commercial and private sitting rooms, with 11 bedrooms'.

By 1898 it had been renamed the Fernleigh Commercial Temperance Hotel and was listed in Whitby's *Yeovil Almanack Advertiser* of that year as a temperance hotel owned by W. H. and E. Whitlock. The hotel was sold in July 1909 and between 1914 and 1919 William Mitchelmore (later Mayor of Yeovil) was listed as the hotel keeper of not only the Albany Temperance Hotel in Middle Street but also the Fernleigh Commercial Temperance Hotel.

By the mid-1930s William Mitchelmore's son Howard was running the Fernleigh. He was listed in Kelly's Directory of 1935 as the proprietor of the Fernleigh Commercial Hotel, which, it was noted, was still a temperance establishment. The Fernleigh Hotel was certainly still open in 1936 as evidenced by several newspaper small ads seeking staff, although at this time the word 'unlicensed' was preferred to 'temperance'.

For many years after the Second World War the old Fernleigh Temperance Hotel was the offices of the Southern National bus company. Its most recent use was as an Indian restaurant and it lay empty for several years. It is currently undergoing refurbishment.

A hand-coloured postcard of 1905 features the Fernleigh Temperance Hotel at the right.

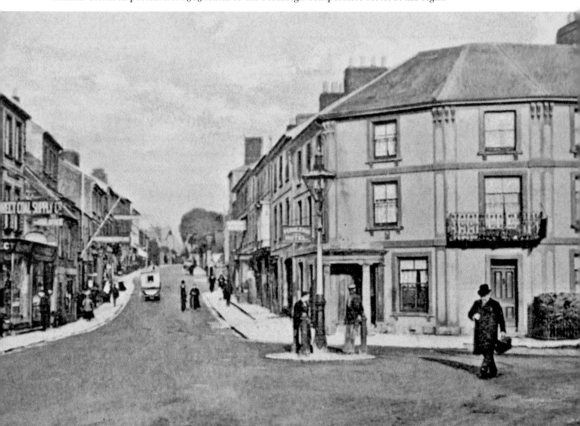

Fire Bell

Early Yeovil was comprised chiefly of wooden buildings with thatched roofs, built close together. Fire spreading from one burning property to its neighbours was a constant threat. In 1449, a total of 117 houses in Yeovil were destroyed by fire, among which were forty-five houses belonging to three of St John's chantries and two belonging to the almshouse. Further fires of a similar scale broke out in 1620, 1640 and again in 1643, when, yet again, many properties in the town were destroyed.

For the early part of the eighteenth century there was no municipal fire brigade and individuals insured their property with a fire insurance company. Each insurance company generally maintained its own fire brigade, which only extinguished fires in those buildings insured by the company, although sometimes in buildings insured by other companies in return for a fee to be paid later. Fires in properties not covered by insurance were not attended unless an insured property was in danger of catching fire as well.

By the 1740s a fire engine was housed in a shed by St John's tower and several dozen leather fire buckets were kept in the church. In 1756, a new item appeared in the churchwardens' accounts for the payment of 2s to George King for '2 stems for ye Fire Crooks'. These were long-handled hooks used to pull the thatch off burning buildings in order to stop the spread of a fire.

In 1848, it was resolved by the vestry: 'That the proposal of the Town Commissioners to take charge of the Parish Engines be accepted, and that the Churchwardens be Authorized to resign them to the Charge of the Commissioners and permit them to take their use the materials of the present Engine house.' Thus the responsibility of maintaining a fire service in Yeovil passed from the Church to the Borough. On the rear of the Town House in Union Street, just below the eaves, remains a bell that was used to summon the fire brigade in times of emergency from the 1840s onwards.

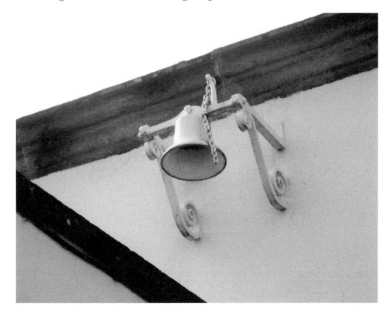

Surviving on the rear of the Town House, this bell was once used to summon the fire brigade.

Gaylard, Frank

Francis W. Gaylard, known as Frank, was born in 1852 in Yeovil. By the late 1870s he had established himself as a hairdresser, initially in premises opposite the Three Choughs Hotel in Hendford.

In Whitby's *Yeovil Almanack Advertiser* of 1878, while at his premises in Hendford, Frank advertised himself not only as a hairdresser but as an ornamental hair manufacturer and wig maker. In Whitby's edition of 1888 he advertised himself as a perfumer and tobacconist, but, more interestingly, he advertised his use of 'Hair Brushing Machinery Driven by Bailey's Patent Hydraulic Engine'. It is illustrated in use in his 1881 advertisement with, presumably, Francis Gaylard himself using it. Frank's hairdressing salon was home to the 'Yeovil & District Toilet Club', from the 1870s until the 1920s.

In the 1891 census, Frank was listed as living in Hendford with his wife Julia and their five children together with a domestic servant. Frank was listed as a hairdresser and all the children were listed as scholars.

By the 1901 census Francis Gaylard was living in Princes Street with Julia and their children: twenty-five-year-old draper's assistant Mabel, twenty-one-year-old Lilian,

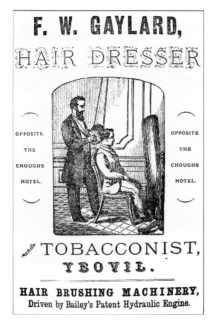

Frank Gaylard's 1888 advertisement showing his hair-brushing machine in use.

fifteen-year-old Ethel, nineteen-year-old William, and a general domestic servant. William was listed as a hairdresser's assistant and Lilian was listed as a hairdresser's shop assistant. Their eldest son, Stanley, had left home by this time. Frank Gaylard died in Yeovil in 1922, aged seventy.

George Hotel

The George Inn began life as a private dwelling. It was built during the 1400s and from 1478 until 1920 it was owned by the trustees of the Woborn Almshouse. The rent of the building provided a regular income for the almshouse.

The George was a timber-framed building over low stone walls with a jettied (that is, projecting) upper storey in the style of a Wealden house. Indeed, the George was regarded as the most westerly example of this style of domestic architecture usually found in the Weald of Kent in south-east England. The form consists of a central hall open to the roof with jettied bays of two storeys at either end. Around the time the building became a tavern, in the mid-fifteenth century, a new floor was inserted in the great hall, making rooms on the new first floor.

The building became an inn called the Three Cups (three cups being the arms of the Worshipful Company of Salters) in 1642. Two years later it is alleged that a traveller suffering from the plague stayed at the Three Cups and the resulting epidemic devastated the population of the town. The Three Cups was renamed the George Inn in the early nineteenth century, probably shortly after the original George Inn in High Street closed around 1841.

The demise of the George, the last remaining secular medieval building in the town, occurred in the early 1960s when the council decided that Middle Street needed widening.

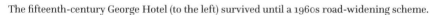

The fifteenth-century George Hotel (to the left) survived until a 1960s road-widening scheme.

The George had to be demolished as part of the road-widening scheme, although this was widely opposed by public opinion. The pub was demolished in 1962, but it transpired after demolition that the council did not own the land so the road-widening scheme could not proceed; consequently, the pavement where the pub had stood simply jutted out into Middle Street as it always had. Within ten years this section of Middle Street was pedestrianised, obviating the need for a road-widening scheme anyway.

Goldenstones Leisure Centre

Sited in the Ninesprings Country Park and off Brunswick Street, the Goldenstones Leisure Centre replaced Yeovil's earlier swimming pool in Huish. The Huish pool had been built in 1960 and was built on the site of Yeovil's first pool, the Corporation Baths, which had originally opened in October 1885.

Goldenstones was constructed in a new stylish and contemporary design, and opened on 1 August 1992. The centre was constructed, owned and originally run by South Somerset District Council, but is now managed by LED Leisure of Exeter.

Goldenstones Leisure Centre features two heated swimming pools complete with a viewing area. The main pool has six lanes and measures 25 metres. The learner pool has stepped entry and both pools are kept at comfortable temperatures at all times. There is a comprehensive programme of lessons for adults and children as well as SwimFit sessions, AquaZumba and Aqua Fit.

The centre also has a large studio, not only for exercise and health classes but also for holiday activities, birthday parties, sports and more. There is a fully equipped gym with over seventy stations as well as free weights. There is also a sauna and steam room as well as a sports shop.

The contemporary architecture of Goldenstones facing Ninesprings park.

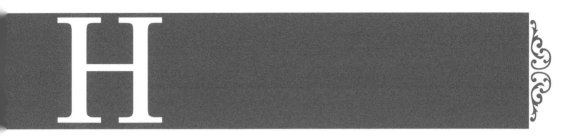

No. 9 High Street

No. 9 High Street was built in 1856, but today only the elevation facing the Borough, in ashlar stone, is the original fabric; the interior was completely rebuilt during the 1980s. The building, erected for the Wilts & Dorset Bank, replaced earlier poor-quality thatched buildings, and as Daniel Vickery wrote in 1856 when the bank building opened:

> Perhaps, however, no part of the borough has undergone more changes in appearance and reality, – dwellings and dwellers – than what is popularly called 'The Borough'. Not long since the site of Mr Dingley's shop was covered by one of the old wood and plaster buildings, and that of the Wilts and Dorset Bank by a block of low mean dwellings.

No. 9 High Street was built in 1856, but today only this elevation is the original fabric.

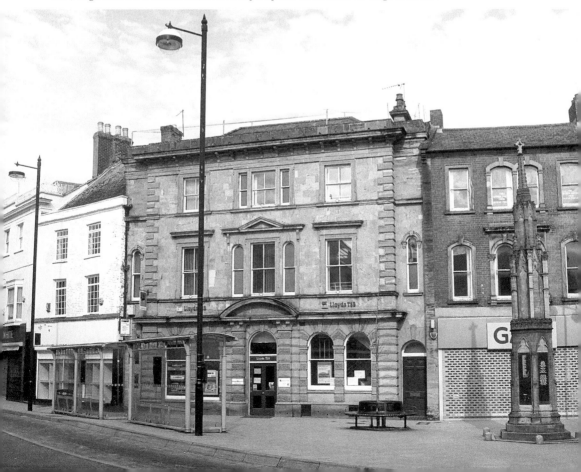

The Wilts & Dorset Bank was co-founded by wealthy glove manufacturer and Mayor of Yeovil, William Bide. The bank underwent many mergers during the latter part of the nineteenth century: amalgamating with the Romsey & Hampshire Bank in 1873, taking over the Bridgwater Bank in 1875, amalgamating with Pinckney Brothers Bank of Salisbury in 1897, etc. It became the Wilts & Dorset Banking Co. in 1914. It is now Lloyds Bank.

Home Guard

During the early days of the Second World War the immediate priorities of the Local Defence Volunteers (renamed the Home Guard on 22 July 1940) were to train and arm the force. They wore simple brassards instead of uniforms, which, in Somerset at least, were not to be issued until the end of July. Training was ongoing throughout the first years of the war under the auspices of the Somerset Light Infantry, who were affiliated for training. Initially, as is well known, men were often drilled with broomsticks in lieu of weapons or else a motley collection of old shotguns, fowling pieces and other improvised weapons. There was urgency in the War Office to equip the force and a few units were equipped with .303 SMLE rifles but there were never enough to go around. In addition, of course, following the evacuation of the British Expeditionary Force, the prime objective was to rearm the army. The initial allocation of rifles to Somerset, for instance, was set at 200 rifles and 2,000 rounds of ammunition for the 6,000 men enrolling during the first week. Nevertheless, the War Office placed emergency orders with Canada for 75,000 Ross rifles of First World War vintage, and with the United States for 100,000 .30 calibre P14 and P17 rifles.

In November 1941, the strength of the 3rd (Yeovil) Battalion, Home Guard, was around 2,500 of all ranks, with the Borough Company strength standing at 369. The company headquarters were at this time in the municipal offices at King George Street, later moving to St Nicholas' School, Penn House. The staff comprised the

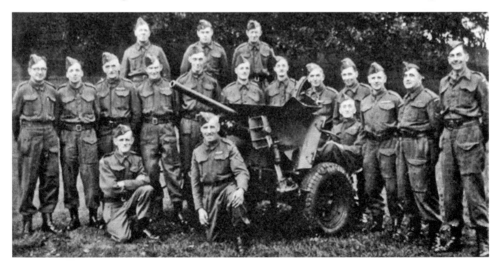

Men of the 3rd Somerset (Yeovil) Battalion Home Guard, Yeovil Borough Company, Q Section, No. 5 Platoon, December 1944.

officer commanding and his staff, his second in command, the company sergeant major and two dispatch riders.

Even when the threat of invasion had passed, the Home Guard remained to give valuable service manning pillboxes and guard posts and carrying out a range of other duties that freed up regular troops for duties overseas. During 1942 the National Service Act allowed for compulsory enrolment where units were below strength. However, following the successful invasion of France in June 1944 and the subsequent drive towards Germany by the Allied armies, the Home Guard was formally stood down on 3 December 1944 and finally disbanded on 31 December 1945.

Horse Pool

In medieval times much of the northern boundary of the Borough was a small stream or brook called the Rackel, or Rackle. The Rackel ran across the road – now the junction of today's Silver Street and Market Street – where there was a shallow ford. In a document of 1355, today's Market Street was referred to as Ford Street. This ford across the Rackel led to Ford Street becoming known as Rackleford, not to be confused with today's Reckleford, which in earlier times was known as Reckleford Hill.

Alongside the Pall Tavern was a pond called the Horse Pool, or Horse Pond, fed by the Rackel, which then flowed out the other side to continue running east. The Horse Pool was used to water horses and was the original site of Yeovil's ducking stool. The Horse Pool, along with the Rackel Stream, was something of a major health hazard and, following a report of the Board of Health on sanitary conditions in Yeovil, both were filled in during the 1850s. Nevertheless, the running water of the Rackel may often still be heard at a road gully opposite the Pall Tavern.

Indentured Servants

The term 'indentured servant' arose in the context of a system for financing immigration to North America primarily during the colonial period. Europeans who could not afford passage to America sold themselves to merchants and seamen in exchange for transportation to the colonies. This arrangement was detailed

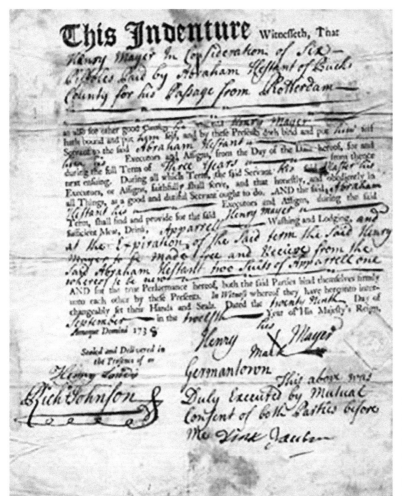

In the seventeenth century becoming an indentured servant was a way of starting a new life in the colonies.

in a contract, called an indenture, in which the emigrant agreed to work without compensation for a fixed term – typically four or five years.

Labour shortages in America's middle colonies enabled indentured servitude to flourish there for more than 150 years. During the seventeenth century most of the white labourers in Maryland and Virginia came from England as indentured servants. In fact, between one-half and two-thirds of white immigrants to the American colonies between the 1630s and the American Revolution had come under indentures. Increased African slave imports during the eighteenth century triggered its decline. By the early 1800s the system had disappeared among Britons going to the United States.

Most indentured servants left England from Bristol, London or Liverpool. In 1654, Bristol City Council passed an ordinance requiring that a register of servants destined for the colonies be kept. Of the total of 10,000 servants in these registers, almost all came from the West Country, the West Midlands or from Wales. Just five came from Yeovil:

- Elizabeth Martine, spinster of Yeovil, indentured for four years to merchant Thomas Gwin of Bristol, to serve in Virginia. 13 July 1657
- Richard Wood of Evill, Somerset, glover, indentured for four years to merchant William Rodney, to serve in Virginia. 10 August 1659
- John Pooler of Yeovil, Somerset, indentured for seven years to John Napper. To serve in Jamaica. Sailed by *America Merchant*. 6 February 1685
- William Fivian of Yeovil, Somerset, indentured for seven years to John Napper. To serve in Jamaica. Sailed by *Dragon*. 2 May 1685
- Walter Summers of Preston [Plucknett], Somerset, indentured for four years to Thomas Kirke. To serve in Jamaica. Sailed by *Dragon*. 2 May 1685

Industrial 'Checks'

Industrial checks or tokens were used to record that a workman was present on a shift, in relation to pay or as receipts for tools issued from a central store. Only two Yeovil companies are known to have produced industrial checks: Petters and Westlands.

Brass checks were issued by Petters Ltd. Around the edge of the obverse is 'PETTERS LIMITED' and 'YEOVIL' around a central nautilus. The logo of the company is based

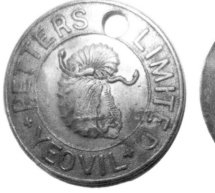 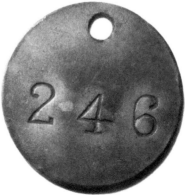

Only two Yeovil companies are known to have produced industrial checks – Petters and Westlands.

on James Petter's Nautilus fire grate. These tokens probably date to the interwar period and were used at the Nautilus Works in Reckleford. Of brass, the tokens are 32 mm in diameter and 1.8 mm thick.

Aluminium industrial checks were issued by Westland Aircraft during and after the Second World War. They are just less than 33 mm in diameter and 1.7 mm thick. Examples are known that read 'WESTLAND AIRCRAFT" around the top and 'JIGS AND TOOLS' or 'SMALL TOOLS' across the bottom. The reverse is invariably plain.

Isaac, Samuel

Samuel Isaac was born in Yeovil in 1783 and his baptism, on 24 July 1783, was recorded in the Yeovil Quaker Register of Baptisms. He was the son of yeoman Samuel Isaac, originally of Montacute, and his wife Eleanor (née Barrett). Samuel and Eleanor were Quakers and married at the Quaker Meeting House in Yeovil in 1782. The family home of the Isaac family was the farmhouse on Reckleford, later to become the Glover's Arms. To give an idea of the extent of the Isaac family's farmlands, which lay north of Reckleford, it stretched from today's St Michael's Avenue to today's Eastland Road and its southern boundary was the whole length of Grass Royal and Mount Pleasant. Part of the farmlands reached Milford Road in the north. Behind his farmhouse was a large 3-acre orchard, now occupied by Earle Street. He also owned a brickyard in

The former Glover's Arms, Reckleford, was originally Samuel Isaac's farmhouse.

Brickyard Lane (today's St Michael's Avenue). The brickyard was sold off and later the White Horse public house was built on the site.

Samuel, a lifelong bachelor, died in Yeovil in the summer of 1849. He was aged sixty-six. His brother Thomas, who owned Grove House in Preston Road, inherited the lands on Samuel's death but sold off the estate within six months.

Isolation Hospital

An outbreak of smallpox in Yeovil during 1870 caused great concern, even though the number of fatalities was relatively small. In February 1893 a visitor to Yeovil brought the disease with her, although in this instance it was contained. Nevertheless, the borough council were concerned enough to commission and speedily erect an isolation hospital. Its first case was admitted in 1895 when a young lad from Exeter visiting a house in Orchard Street was diagnosed with smallpox. The disease was contained and the boy eventually recovered.

The hospital was built in 1893 by Yeovil Borough Council and the medical officer's report on the sanitary conditions of Yeovil in 1904 described it as follows:

> The Isolation Hospital, a red brick building, situated 1½ miles from the centre of the town at its extreme east boundary; is 500ft distant from the road and from any dwelling. It was erected in 1893 at a cost of about £400. It contains in its two wards 8 beds; a Laundry, Ambulance and Mortuary block was added in 1903 at a cost of £142; total cost £542.

The hospital was taken out of use in the early 1930s and during the Second World War served as a mortuary for air-raid victims and as a hostel for 'difficult' evacuee children. The building was finally demolished in the 1960s and today the site is approximately halfway along Buckland Road, on the Pen Mill Trading Estate.

Jesty, Thomas

Thomas Jesty was born in Yeovil in 1852, the son of carpenter John Jesty and his wife, Mary Ann. In the 1861 census John, Mary and all six of their children were living in Coalpaxy Lane (today's Sparrow Road).

In the autumn of 1877 Thomas married Sarah Stevens of Wiltshire – nine years his senior – at Yeovil. Thomas had clearly acquired some of his father's carpentry skills since in the 1881 census he was listed as an 'Undertaker & Furniture Dealer'. Thomas and Sarah were listed at No. 88 Middle Street and living with them was nineteen-year-old Benjamin Stevens, a printer's compositor who was listed as Thomas' son-in-law but was actually his stepson. They also had a general domestic servant. In the 1891

Thomas Jesty's furniture emporium was filled to the rafters with his wares.

census Thomas and Sarah had nineteen-year-old William Stevens living with them, as well as a general domestic servant.

Thomas placed advertisements in Whitby's *Yeovil Almanack Advertiser* from 1889 onwards. He had two separate listings in the 1895 edition: one as an undertaker of Middle Street and the other as a cabinetmaker of Middle Street. His last listing was as 'T Jesty, House Furnishers of Middle Street' in Whitby's 1903 edition.

In the 1901 census Thomas and Sarah were listed living above the 'Furniture Warehouse' in Middle Street with their grandson William Stevens and a general domestic servant. Thomas' occupation was listed as 'Cabinet Manufacturer'.

Thomas died early in 1904 in Yeovil and the business was renamed Jesty & Co. after his death. It was then run by his wife Sarah and her son by her first marriage, William Stevens, who was to run the business until at least 1965.

Jubilee Cottages

Jubilee Cottages were old thatched cottages in Preston Road standing directly opposite Watercombe Lane. The name derived from the Jubilee Tree, a lime tree planted in Preston Road in a triangular traffic island at the head of Watercombe Lane, opposite the terrace of cottages, to commemorate the Golden Jubilee of Queen Victoria in 1887. Its trunk was protected by a circular iron fence.

In the 1920s the cottages were home to the Pollard, Hallett, Higdon, Montacute, Barton and Beare families. At the end of Jubilee Cottages was the entrance to Bowerman's slaughterhouse and more open fields. The cottages were demolished in 1938.

Jubilee Cottages, opposite the Jubilee Tree junction, from a postcard of the early 1930s.

Kate Bridge

Kate Bridge, also known as Cake Bridge, was a bridge that carried Newton Road over Dodham Brook, just to the south of today's bridge. How the name of Kate Bridge arose is a complete mystery. There may be a connection with the Harbin family of Newton Surmaville who owned the land the bridge was on; they certainly had at least two generations with daughters by the name of Katherine in the seventeenth century. However, the earlier 1589 *Terrier* refers to 'Cake Bridge'. The 1743 *Terrier* makes reference to 'Dodham to Cake Bridge', but the churchwardens' accounts, also for the year 1743, has several entries for payments in connection with 'Kate Bridge'. The 1743 account entries are as follows:

Paid Jno Marshell for works done in repairing Kate Bridge	£1 16s 0d
Paid for Lime used about the Said bridge and Carriage	13s 4d
Paid Mr Gerrads for hampdon hill Stone for Kate Bridge	£1 16s 6d
Paid Ralph Clarke for Clamps used about Kate Bridge	4s 6d
Paid Wm Cockey his bill for work done on the School and Kate Bridge	£1 1s 8¼d
Jno ffrench for a Sive use about Kate Bridge to Sift the Lime	1s 0d
Paid farmer Newman for Carriage of a Load of Hampton hill Stones for Kate Bridge	8s 0d
Paid for 5 load of Stones about Kate Bridge	£1 0s 0d
A Load of Stones from Hampton hill to Kate Bridge	8s 0d
Carrying of sand	6s 0d
Peter Hart's bill for Beer for the Labourers about the Bridge	11s 3½d

Also in 1743, the minutes of a vestry meeting recorded yet another variant spelling: 'do order Mr Onesiphorus Penny and Mr Philip Francis, the present Churchwardens, to repair the lane from the lower part of Mr Thomas Hayward's Barn to Cate Bridge.'

When the Town station was built in 1860 Cake Bridge was demolished, Dodham Brook was diverted into a culvert under the road and the present Newton Road Bridge was built.

King George Street

King George Street, named after George V, was constructed between High Street and South Street in the early 1920s just east of George Court – an alley so named because it originally ran behind the George Inn, High Street. Initially, only the municipal offices were constructed along the western side of the new King George Street, running alongside the Town Hall on High Street, and opened in 1928.

This building in King George Street, originally Yeovil's main post office, opened in 1934.

The municipal offices were designed and built by local architects Petter & Warren. The building is neo-Georgian, of fifteen bays' width and two storeys with a cupola. Unfortunately, the Town Hall and most of the Market House was destroyed by fire in 1935 and the only part of it remaining is a small portion of the wall behind Borough Arcade.

A municipal museum was created above the Borough Library at the southern end of the new municipal buildings, chiefly in order to display the Roman finds from the Westland Roman Villa site, including the mosaic floor. The library was replaced by a new purpose-built building in 1986 on the south-east corner of King George Street.

The buildings on the eastern side of King George Street were not opened until 1932 and were all initially occupied by the post office. Barclays Bank took over part of this building in 1965.

Kingston Toll Gate

In 1753, turnpike commissioners were appointed for 'repairing and widening the roads' of Yeovil. They ordered that 'three capital gates be erected' at Hendford Bridge (by today's Railway Tavern), Goar Knap (roughly near the junction of St Michael's Avenue and Sherborne Road) and 'the Head of Kingston'. There was also a 'stop gate near the entrance leading from Pen Style to Newton' with others at Watercombe Lane, Combe Street Lane, Goldcroft and Dorchester Road.

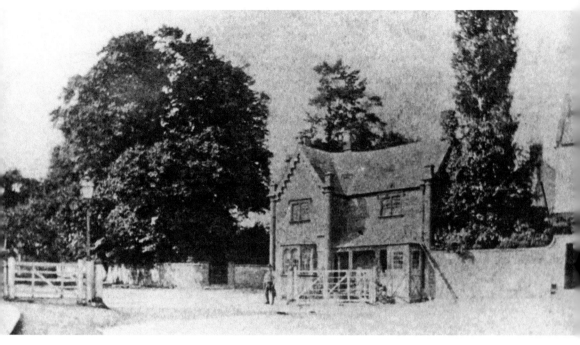

Kingston Turnpike House and gates, photographed around 1860 by Henry Goodfellow.

Richard Slade was elected collector of tolls at Kingston Gate and, in common with the other collectors, he was paid a 'salary of 6 shillings per week, or 8 shillings until the completion of the house'.

On 25 January 1781, the town commissioners ordered 'that an engine for weighing carts, waggons and carriages with goods or merchandise be erected at the Kingston Gate'. The engine was erected and first used on 28 May 1781, the gatekeeper being empowered 'as an encouragement to his attention and care of the roads to take three pence a carriage, but not less' for weighing them.

By 1850 the toll paid for a horse not drawing was 1½d and drawing, that is, pulling a cart or suchlike, was 4½d (58p and £1.73 at today's value). A new tollhouse was built for the toll collector by Kingston Gate, where Fiveways roundabout is today, probably in 1856. When the Yeovil Turnpike Trust was abolished in 1875 the tollhouse was taken down stone by stone and re-erected around a hundred yards further down Kingston. At the same time all of Yeovil's toll gates, stop gates and side gates were removed. The Kingston Turnpike House was demolished for the second and final time in 1969 when Kingston was widened and the site was cleared for the construction of Yeovil District Hospital.

L

Lambe, Markes

Markes Lambe was born in 1776 in Somerset, most likely in Bath. He was the son of grocer Mark Lamb and his wife Mary, who had a shop in Stall Street, Bath. By 1791 Mark Lamb Snr had died and the business was being run as Mary Lamb & Son. An advertisement in the 21 July 1791 edition of the *Bath Chronicle* announced that Mary Lambe had taken her son into partnership. From other advertisements of the time it is clear that, in addition to fresh teas, they also sold prime wax candles and spermaceti candles as well as Wheble's Kensington Moulds (Wheble's being a famous London candle manufactory).

Markes left the business and was married, probably around 1802, settling in Beaminster, Dorset. His wife's name was Ann and they had at least one child, Mary Ann, born in 1805 at Beaminster. After leaving Bath, Markes trained and qualified as a surgeon and was listed in the 1811 edition of the *London & Country Directory* as a surgeon of Beaminster, Dorset.

A lease dated 9 November 1815 indicates that Markes was living in Yeovil at this time since it notes he was renting a property in Hendford (Nos 1 and 3 Princes Street today), which he used as his home and medical practice for the next ten years. In 1820, the lease Markes' mother had for her shop premises in Bath passed to Markes, who was described in the lease as a surgeon of Yeovil. Pigot's Directory of 1822 listed him as 'Mark Lamb, Surgeon of Henford'.

The 4 April 1846 edition of the *Bristol Mercury* announced Markes' death: 'March 22, at Yeovil, aged 70, Markes Lambe Esq. Surgeon'. He was buried in Sherborne.

Nos 1 and 3 Princes Street, the former home and surgery of Markes Lambe.

Larkhill Road Prefabs

After the Second World War Britain had a major housing shortage. In a radical solution, the government built thousands of prefabricated homes, or 'prefabs', as a temporary replacement for housing that had been destroyed by bombs. Around 150 were built in Larkhill Road over a six-week period in late 1946.

The single-storey prefabs were manufactured off-site in advance in standard sections that could be easily shipped and quickly assembled. The advantage over traditional housing was its exceptional speed of completion, combined with a comparatively very low cost. Indeed, the record time for completing a prefab, including all services, was under an hour. Built on top of pre-plumbed concrete slabs, these Yeovil homes were often built by teams of Italian prisoners of war who were in no hurry to return home. In fact, much of Larkhill Road itself and some other Yeovil roads were built by Italian prisoners of war.

Despite the intention that these dwellings would be a strictly temporary measure – they were designed to last for ten years – many remained inhabited for decades after the end of the war. Indeed, the majority of the Larkhill Road prefabs were demolished in the 1960s.

The prefabs had two bedrooms and storage was provided by built-in wardrobes. There was also a hallway, living room and a fitted kitchen with hot and cold running water, a cooker and a built-in refrigerator – a luxury for most people at that time. It also boasted a fitted bathroom with a heated towel rail and a separate indoors toilet – another luxury and something often missing in 'normal' homes of the time. The coal fire in the living room had a back boiler that heated water for the bathroom and kitchen and also provided ducted warm air to the bedrooms.

The major complaint of those who occupied the prefabs was that they were often damp and were very difficult to heat in winter and became too hot in summer. In 1956, it cost £1 6d rent per week, including rates and water (just over £22 per week at today's value).

Prefabs on Larkhill Road photographed around 1960.

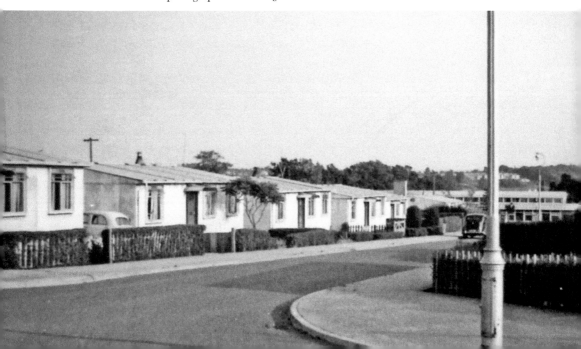

Larkhill Stadium

Yeovil had a long tradition with coursing and actually had four venues for greyhound racing. Greyhound racing took place around the famous sloping Yeovil Town Football Club pitch in Huish from as early as 12 May 1928.

In August 1931, Barwick Fields south of Yeovil became a venue for greyhound racing. The location is believed to be somewhere near to Barwick Park. Here 525-yard events were held, which continued until early 1932 when the racing seems to have moved into central Yeovil. Racing became more regular in 1932 when the track known as West Hendford seems to have replaced the Barwick Field events. This may have taken place at the field later known as the cricket ground and used for county cricket matches between 1935 and 1939.

On 5 February 1947, a betting licence was granted to William James Parsons of Wyndham Street for a 'proposed greyhound racing track at Higher Larkhill', although the licence was transferred to Mr F. P. Harding of Bristol in October 1947. The purpose-built greyhound track was based at the Larkhill Stadium on Larkhill Road and first opened its gates in 1947. It was built on fields that had originally been part of Larkhill Farm. The stadium was able to accommodate a significant 20,000 people and there was a licensed club and bar. Racing was on Tuesdays and Fridays at 7.30 p.m. The track circumference was 430 yards with race distances of 330, 530 and 730 yards. The centre of the track was used for other sports including a football pitch. The senior team of the popular St John's Gym and Boys Club latterly played their home matches in the Larkhill Stadium.

Planning consent for housing was sought in 1971 and the stadium closed in November 1972. The track was run independently until its closure. By 1974 the stadium was built over and today the site of the stadium is covered by housing around the Larkspur Crescent area.

Larkhill Stadium was Yeovil's greyhound track from 1947 to 1972.

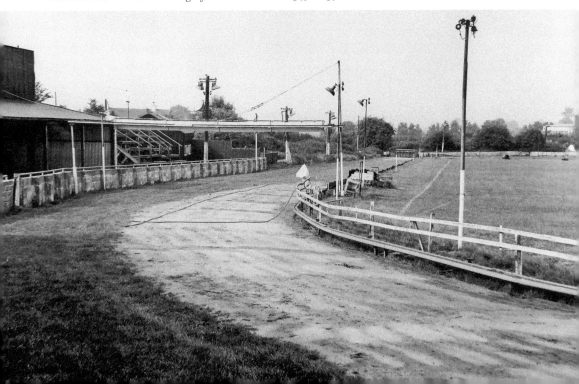

Lydegurl

'Gurl' – also found spelt goyle, goil, goyal and guile – is a Somerset dialect word meaning a ravine, gully or steep-sided narrow valley, usually with a stream running down it. Lydegurl was the valley formed by Lyde Brook, which formed the southern boundary of Lyde. Indeed, the name Lyde itself derives from the Old English *hlyd* or *hlyde*, meaning a steep-sided watercourse which, of course, neatly describes Lydegurl.

The 1589 *Terrier*, referring to the boundaries of the great medieval East Field of Kingston Manor, recorded 'from Stoney lake down by Lydegurl to the Great River' and the 1743 *Terrier* referred to 'The Guile'.

Lyde Brook formed the boundary between Lyde (essentially Great Lyde Farm) and the great East Field of Kingston Manor for centuries. It rises in the area just south of today's Runnymede Road, between Rivers Road to the west and Magna Close to the east. It then flows south-east and turns east in the area of Birchfield School fields, continuing east until it flows into the River Yeo. Over centuries the stream had cut a steep-sided narrow valley – the gurl.

Many of us can remember when Lyde Road stopped at the valley, which, during the 1970s and 1980s, was the council's rubbish dump. Lyde Brook was piped through the valley while an endless stream of refuse lorries dumped their loads of the town's rubbish into the little valley – today politely called 'landfill'. The valley was eventually grassed over and Lydegurl almost disappeared forever. Nevertheless, the last 50 yards or so of the Lyde Brook is still visible as a steep-sided watercourse as it joins the River Yeo.

The steep-sided ravine, or gurl, survives today where the stream approaches the River Yeo.

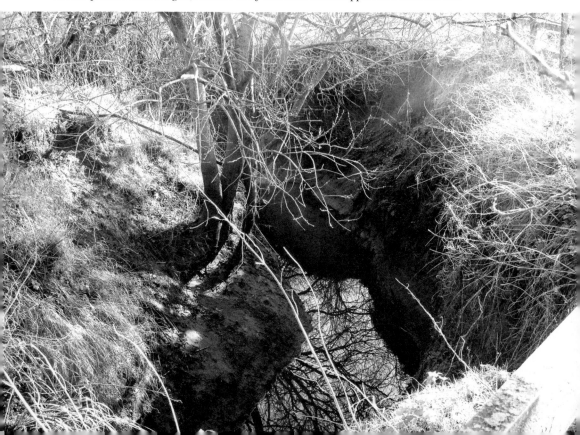

M

Market House

The Market House stood in the Borough and was built in 1740 by Lady Elizabeth Phelips of Montacute House. It was located near the south-east corner of the Borough, close to the entrance of Wine Street, then known as Grope Lane. Essentially a tiled roof on twenty stone pillars, the Market House was open on all sides and offered a little protection from the elements for street traders. The building was 70 feet long by 20 feet wide (21.3 metres x 6 metres). The town stocks were housed within the structure.

In its 1 May 1766 edition, the *Bath Chronicle & Weekly Gazette* reported:

> We hear that the Inhabitants of Yeovil, on account of the Repeal of the Cyder-Act, and the Prohibition of the Importation of French Gloves, (Gloving being the principal Trade of that Town) have devoted the greatest Part of the last Week to Bell ringing and other Diversions; three Sheep being roasted whole on the last three Days, and two Vessels of Cyder continually running at their Market-House.

By the mid-nineteenth century the Market House, as well as the adjacent Butchers' Shambles, had fallen into disrepair and their demolition was the subject at the first meeting of the newly established special commissioners in 1846. Both the shambles and the Market House were demolished in 1849 with the special commissioners contributing £200 towards the costs.

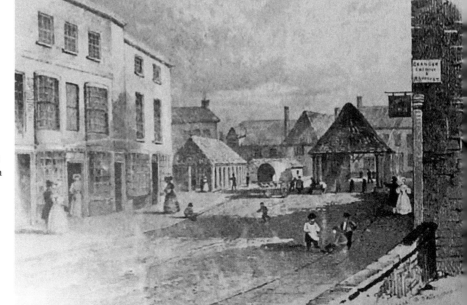

Yeovil's Market House in the borough is seen to the right with the Butchers' Shambles to the left.

Mayo, John Ryall

John Ryall Mayo was born in 1792 at Nether Compton, the son of yeoman farmer George Mayo and his wife, Christian. She was the daughter of wealthy glove manufacturer John Ryall and owner of Old Sarum House in Princes Street. In 1814, John Mayo married Elizabeth Whitmash Randall and they had four children. Elizabeth died in 1822 and in 1824 he married her cousin Penelope Worsfold Randall. They had a further five children.

In 1818, John Mayo inherited Old Sarum House on the corner of Park Road and Princes Street. In the 1841 census these were called Mayo's Lane and Hendford respectively. Since the original Borough boundary had run along the centre of what is now called Princes Street, the buildings on the western side were known as being in Hendford.

Mayo's house was one of the properties attacked and damaged by the mob of hundreds of protesters in the Yeovil Reform Riot of Friday 21 October 1831.

In 1821 and 1822, Mayo served as a churchwarden of St John's Church. He was also a trustee of Woborn's Almshouse, became a surveyor of highways and was nominated, like his brother George, as a town improvement commissioner. The two Mayo brothers, together with John Greenham (glove manufacturer, burgess and Portreeve in 1797), were exceptional in their work as commissioners. After Greenham's death in 1838, John Mayo acted almost continuously as chairman until the commission ceased to exist when Yeovil became a municipal borough in 1854.

John Ryall Mayo was an influential glove manufacturer. He was a member of the vestry and also a town commissioner and his duties as commissioner were very much involved with street widening and, as an example, he surrendered part of the forecourt of his house – Old Sarum House – for that purpose. He became the first Mayor of Yeovil in 1854. Shortly afterwards the Lord Chancellor appointed Mayo as magistrate for the borough. He died in Old Sarum House on 6 February 1870 aged seventy-seven.

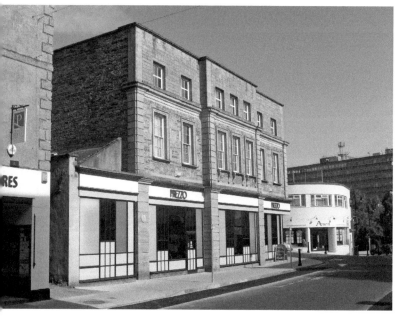

Old Sarum House was John Ryall Mayo's home until his death there in 1870.

Middle Street

From the fourteenth century that part of present-day Middle Street running from the Borough to the Triangle was known as Pit Lane or Pyt Lane, probably because of a number of flax pits or tanning pits were in the vicinity. A document in the Woborn Muniments, dated 1367, refers to it as 'the royal strete de la Put'. In 1419, Middle Street was called Putlane in a deed for 'a messuage with a curtilage adjoining, belonging to the chantry of the Holy Trinity of Yevele, within the free borough of the said town, in a street called "Putlane". It was still being referred to as Pit Lane as late as the middle of the nineteenth century.

The area today called the Triangle (but in earlier times known as Vennell's Cross) is where Middle Street, South Street, Vicarage Street, Stars Lane and Fore Street (Lower Middle Street) meet and was originally the easternmost point of the borough of Yeovil.

Part of the medieval borough, Middle Street had originally been very narrow indeed and lined with irregularly sited and mostly thatched houses, which contributed greatly to its destruction through a series of fires. There were also a number of unsavoury 'courts' or infill housing for the very poorest families, such as the infamous Dean's Court where eight houses shared one privy that was so close to the court's well that water in the well became contaminated by the leaking privy. The road was largely unpaved and had an open ditch, called a 'sewer', until at least the eighteenth century.

Two medieval buildings survived, the Castle Inn and the George Inn, but both were demolished in the twentieth century for street widening – until 1958 Middle Street was part of the A30 London to Exeter trunk road. The Castle Inn, demolished in 1928, was to be the site of a cinema but it was never built. The George Inn was demolished in 1962 for street widening, although that section of Middle Street was pedestrianised around ten years later.

This hand-tinted postcard of Middle Street dates to 1904.

New Prospect Place

New Prospect Place was built between 1814 and 1829 at Goar Knap. It was also known as 'The Colony' and is listed in the 1841 census as 'Jenning's Buildings' – named for the person who built them, Robert Jennings and his son William Jennings who owned them after the death of his father in 1848.

New Prospect Place was a long terrace of very tiny cottages that were little better than slums and occupied by the very poorest families. The 1841 census lists a total of 143 people, but, being farther from the centre of the town with its gloving factories, most of the men were labourers or agricultural labourers and it was the women who were gloving outworkers. Several people were described as paupers. At the last count, in the 1901 census, there were still 137 people living in New Prospect Place.

In 1906, the medical officer of health reported to the town council that it comprised fifty-two houses in 'wretched repair', some of them 'in very dilapidated condition'. The 200 inhabitants of these houses shared just twelve toilets or 'closets', which were so built that anyone using them with the door ajar could be seen by people passing up or down the street. Laundry had to be done outdoors, under one of the six water taps that served the fifty-two houses. There was nowhere to deposit ashes from the fires that heated the houses, and although domestic rubbish was removed periodically by the council's scavenging team, there were no proper dustbins or receptacles.

Most of the houses had dirt floors, which were often flooded because of the roadway in front of the houses had inadequate drainage. The road had no proper surface and was riddled with potholes in which rainwater and dirty water from the gullies beneath the six communal taps quickly accumulated.

Conditions were appalling, and as a result of the report the town council decided to have the houses cleared away. Even so, they were not demolished until after 1911 and the land used as allotments, as it is to this day.

Newton Surmaville

The estate of Newton Surmaville came to the Burnell family in 1442. John Burnell sold the estate to John Compton in 1510. His grandson, another John Compton, sold Newton to Robert Harbin of Wyke, near Gillingham, Dorset, in 1608.

A prosperous and wealthy mercer, Robert Harbin (1526–1621) began acquiring a number of small properties in Dorset and Somerset. His final purchase was in 1608 when he purchased an estate from Joseph Compton. The estate, to the south-east of the town of Yeovil, was known as Newton Surmaville, named after a French family,

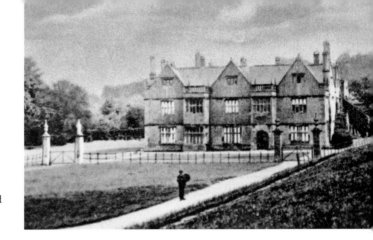

A pre-1914 hand-coloured postcard of Newton Surmaville, the Harbin family home for 399 years.

the de Salmonvilles, from a small village near Rouen, who first built a medieval house on the site where the current house now stands. Robert Harbin and his eldest son, John (1560–1638), commissioned the building of a new grand country house at Newton, which was completed around 1612. Robert and his son John moved into Harbin Castle, later called Newton Surmaville House.

The house remained in the Harbin family for 399 years, through more than ten successive generations. Following the death of Sophie Rawlins (née Sophie Wyndham Bates Harbin), Newton Surmaville House was sold in 2007 – for the first time in its history.

Ninesprings

Ninesprings is a broad-leaved woodland valley of some 20 acres on the south-east edge of Yeovil. It has, as the name would suggest, nine springs supplying water to small streams and ponds. The water issues into Dodham Brook and, ultimately, to the River Yeo.

In 1856, Vickery wrote: 'John Batten, Esq, and at Nine Springs, the property of the same gentleman. These springs afford a large supply of water, from two to three hogsheads a minute at least, and were they at an elevation sufficient to supply the town, they would be of great value.'

It was developed as an ornamental park for the Aldon estate during the early nineteenth century (although its ownership was brought into question at the time of the Yeovil charities scandal) and included walks, bridges, grottoes, springs and lakes. Until the middle of the twentieth century the public only had access by ticket obtainable from the owner, Colonel H. B. Batten, the town clerk.

The picturesque thatched cottage that appears in so many photographs of Ninesprings once served cream teas. The cottage suffered neglect during the Second

The beautiful Ninesprings Lake is now part of the Yeovil Country Park.

One of the many delightful pools higher up in the Ninesprings valley.

World War and was allowed to quietly fall into ruin. It was finally demolished in 1973, although the foundations are still visible.

Ninesprings was acquired by the district council in the 1970s and now, having been restored, has been incorporated into the 127-acre Yeovil Country Park.

Nuns' Well

Nuns' Well, sometimes called Stairs Well, was a public well (Yeovil didn't have mains water until the middle of the nineteenth century) in Silver Street, on the west side between the steps to Church Terrace and North Lane. It was most likely named for the nuns of the convent of Syon in Middlesex, who held the lordship and rectory of Yeovil from 1450 until the Dissolution of the Monasteries. Nuns' Well was in the manor of Hendford, while Miller's Well, just yards away in Rackleford (today's Market Street), was in the manor of Kingston.

The well is mentioned in the churchwarden's accounts when it was repaired in 1568 with 'a Post to bear the railes of Nun Well and a Staple and nails for the same,' which cost a shilling. It was repaired again in 1733 when 6s was 'Paid for Postes and Railes for Nun Well'. That the Nuns' Well was fenced in and had a gate is verified in an entry in the churchwardens' accounts of 1805 when they paid £1 12s to local builder Thomas Churchouse 'for 4 Oak Posts against Nuns Well & Morticed' plus 9s 11d for 'Mr Churchouse's Bill on for Ditto 34 feet Oak Rails @ 3½' and 9s 6d for 'Ditto An Oak Gate to the same by Nuns Wells" with 5s od for "Labour about the same'.

In 1852, in his report to the General Board of Health concerning, among other items, Yeovil's water supply, Thomas Rammell wrote: 'The well or spring in Rackleford [Miller's Well], gives a small supply of very pure water. It finds its way from under the side of the rock, or limestone strata. The well at the Church Steps [Nuns' Well] is under similar circumstances, that is, the water finds a passage between the rock and the compact indurated clay, marl, etc. immediately beneath it.'

In 1851, there were 113 wells and pumps in Yeovil. Other than Nuns' Well, the principal wells of the town were Dick's Well and Rustywell, both in Hendford; Miller's Well; Bide's Well in Kingston; Cave's Well in Princes Street; Turner's Well and Hannam's Well, both in High Street; and the Gasworks Well. But, to quote Vickery: 'Several wells in the town are contaminated by the soakage from private sewers, deposits of offal, refuse of skins, and other filth.'

O

Octagon Theatre/Westlands Entertainment

The Octagon Theatre was originally called Johnson Hall after a major donor to the town's fund for a new civic hall, W. Stanley Johnson. Building began in 1972 and Johnson Hall opened in July 1974 as a multi-use civic hall. In 1985 the hall was renamed the Octagon Theatre and in 1988 the building was converted to a single-use theatre, which it remains today.

By converting to a single-use theatre, the opportunity was lost to host other types of promotions such as dances, groups and bands, festivals, cinematic performances, etc. As a consequence, the old Westlands Sports and Social Club was completely refurbished and opened as the Westlands Entertainment and Conference Centre in March 2017. It is run in conjunction with the Octagon Theatre, thereby dramatically increasing the range of possible events held in Yeovil.

The new centre – fully wheelchair accessible – has a ballroom that may be converted into several configurations, for conferences, dinner dances, shows, bands, cinema performances and other theatrical productions as well as private functions. The ballroom has its own bar but there is also a separate large bar area that also offers snacks.

The Westlands Entertainment and Conference Centre is the latest of Yeovil's many facilities.

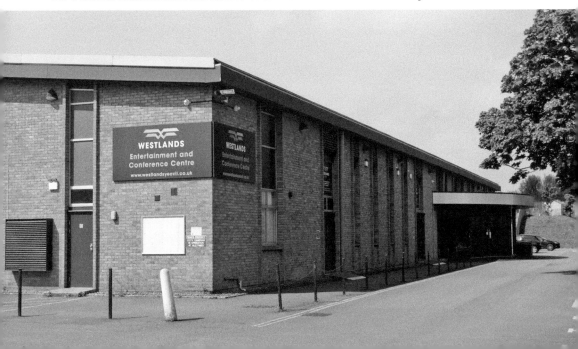

Orchard Street

In the 1846 tithe apportionment Daniell's Orchard was recorded as being owned by Jane Newman and Berkley Newman was the tenant. Indeed, much of today's Yeovil was covered by orchards at the time.

Orchard Street was a development started in the mid-1890s by a local businessman, town councillor and local 'character' Levi Beer. He named Orchard Street after Daniell's Orchard, which it was built on.

Levi Beer was also responsible for building Beer Street, named after himself. When the name was approved by the council, one wit remarked that 'Cider Street' might be more appropriate. Levi Beer was fervently against party politics; he was locally famous for his election slogans such as 'Don't vote for water, vote for Beer' and, on standing for election in Queen Victoria's Jubilee Year of 1887, his election slogan was 'No cold-water Jubilee – vote for Beer'.

Orchard Street appears on the 1901 Ordnance Survey as nearly complete, but of course, Westland Road didn't exist. Beer Street was at this time under construction and continued north to join up with Huish. At this time Huish ended at the junction with Grove Avenue, with fields beyond.

Orchard Street, seen here in the 1980s, was built on the site of an old orchard.

P

Palace of Varieties

The first public showing of a film in Yeovil was at the Assembly Rooms in Princes Street in 1896, and the Central Auction Rooms in Church Street followed in 1912, renamed the Central Hall Cinema in 1916. However on Monday 10 February 1913, at 8 p.m. at the Palace of Varieties, Yeovil's first purpose-built cinema opened. It was built on the site of what was essentially slum housing known as Pashen's, or Patience, Court. The *Western Gazette* reported on 14 February 1913

> On Monday evening, the new picture theatre, which has been erected in The Triangle for the Yeovil Picture Palace Ltd, was opened, and the smart little house was crowded with an audience that included a large number of the leading residents, members of the governing body, and Borough officials.

Yeovil's new cinema was the brainchild of early cinema entrepreneur Albany Ward. The Palace of Varieties was designed by F. B. Brigg, architect of Yeovil and Frome, and built by Yeovil builder F. R. Bartlett. The name Palace of Varieties was not new to Yeovil and had been the name of the Assembly Rooms in Princes Street around 1905.

Albany Ward went out of business in 1919 and his cinema and theatre chain was sold to Provincial Cinematograph Theatres Ltd, at which time it was renamed the Yeovil

Albany Ward's Palace of Varieties, Yeovil's first purpose-built cinema, opened in 1913.

Palace Theatre. In February 1929 the Provincial Cinematograph Theatres Ltd was taken over by Gaumont. The Palace Theatre was closed and the building demolished in 1934 to be replaced by the new Gaumont Palace in 1935.

Pall Tavern

A pall, or mortcloth, is a cloth that covers a coffin at funerals. The sign of the Pall Tavern in Silver Street was based on an elaborate pall owned by the Woborn Almshouse that was hired out for such occasions. The Pall Tavern should be pronounced the 'Paul' Tavern. The original Woborn Almshouse, founded in 1477, was situated just behind the property that was to become the tavern. The site is occupied now by an Indian restaurant.

The Pall Tavern (as well as the Three Choughs Hotel and the George Inn) was owned for centuries by the Woborn Almshouse and the rent of the building provided income for the almshouse. The medieval almshouse had become so ruinous by the 1850s that the new Woborn Almshouse was built in 1860 at its present site on the junction of South Street and Bond Street. It is not really clear when the Pall Tavern first opened its doors: the current building only dates from 1836, but its predecessor had been trading for many generations.

The first record in which the Pall is mentioned as an inn as opposed to a private dwelling is in a lease dated 1769 in which it was claimed to be 'in very ruinous condition'. In 1796, the Woborn Almshouse account book lists Mrs Kitson as paying 16s rent for the George in Middle Street, another almshouse property, while she was already renting the Pall.

The Kings Arms Inn, four doors away, had also stood for many years in Silver Street, but a major fire in 1835 destroyed it along with several other premises. Following the fire, all the premises from the Kings Arms to and including the Pall were rebuilt further back from the road so that Silver Street could be widened, thereby easing congestion in the centre of the town.

The Pall has been operating for centuries but the present building dates from 1836.

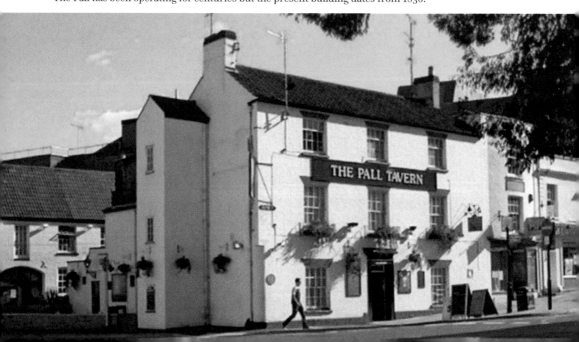

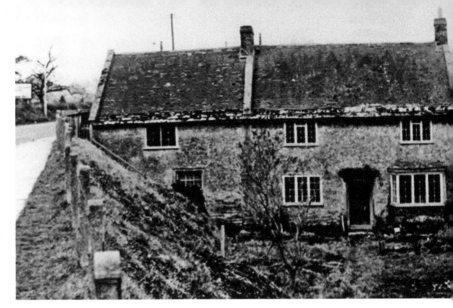

With the coming of the railway, the Pen Mill Inn was half-buried by the new road bridge.

Pen Mill Inn

Very little is known about the Old Pen Mill Inn other than it was originally cottages adjacent to the London Road (now Sherborne Road) and completely surrounded by fields and orchards. The will of Henry Whiffen 'of Pennmill Inn' is dated 14 May 1790. It was listed as the Pen Mill Inn at least as early as 1828 and was a long-established cider house.

From notices to attend the manorial court in 1815 it is known that the Pen Mill Inn was also known as the King's Head Inn since the court was 'to be held at the house of William Jeffery known by the name of the King's Head, Pen Mill'. This was concurrent with the King's Head in High Street.

It is also known, from a list of builders' and tradesmen's charges, that the Pen Mill Inn was rebuilt between 1822 and 1823. The building was built at right-angles to the road. One half of the new building was a cottage and the other half, next to the road, became a fully licensed public house, predating the 1830 Beerhouse Act.

The railway bridge built in 1860 at Pen Mill station necessitated the raising of Sherborne Road, half-burying the old inn. Unfortunately, the new bridge caused the Pen Mill Inn to be cut off from the road and consequently lost its trade. By the time of the 1861 census, just two years later, the licence had been transferred to the newly built Pen Mill Hotel and it was described as 'Pen Mill Old Inn'. It was finally demolished around 1961 and the area is now under landscaping in the eastern corner of the Pittard's factory site. At the time of its demolition the licensing inscription was still above the doorway, bearing the name of the last licensee, George Frost, who was licensed to 'brew and sell beer'.

Preston Great Farm and Barn

Preston Great Farm, or Preston Higher Farm, commonly known as Abbey Farm, was the manor house of Preston Plucknett. It was never an ecclesiastical building but the mistake was made by Lady Georgiana Fane when she inherited the property in 1841 and has been perpetuated to this day.

The house and barn (the longest in Somerset), both built in Ham stone and now Grade I-listed buildings, are thought to have been built by John Stourton during

the reign of Henry V (1413–22). Stourton was a Justice of the Peace, sheriff, and several times MP for Somerset, who, helped by three good marriages, accumulated a respectable wealth. The manor was left to his third and surviving spouse, Katherine Payne, and eventually inherited by his three daughters.

During this period an agricultural depression caused by a shortage of labour led to much arable land being converted to sheep runs, to satisfy the increasing need for wool and cloth for export. Wool was big money and Stourton was in the trade. In 1403, John Stourton married Joan Affeton, a widow from Devon and doubtless wealthy. So, very soon he built himself a grand new manor house to rival the smaller house built by the D'Evercys in neighbouring Brympton. The new barn was needed too, not only for storing his wool but for flax and hemp as well – both valuable crops.

His affairs prospered and by 1430 he had bought Brympton, some 400 acres, from the Wynfords, and soon afterwards the manor of Pendomer some 3 miles to the

The Great Barn (to the left) and Preston Great Farm were both built around 1420.

The Great Barn is the longest barn in Somerset.

south. No doubt his second and third wives brought him marriage settlements. Each bore him a daughter, but since he had no sons the Stourton name died out. However, a field in Preston is called Cecily Bush, named for Cecily, the daughter who inherited the manor on her father's death in the 1440s.

Public House 'Checks'

Public house 'checks', a type of trade token, were frequently used in pub games, such as skittles or quoits where, for instance, players would chip in a check to the kitty, which would be won by the winning team to redeem at the bar. By issuing these checks the landlord could guarantee they would only be spent in his establishment. The great majority of Yeovil public house checks are from the late Victorian period.

The photograph shows the obverse and reverse of three examples of Yeovil public house checks. From left to right they are:

- A public house check issued by John Reed when he was the proprietor of the Mermaid Hotel – he was only recorded there in 1897. On the obverse is 'MERMAID HOTEL' above 'J REED' above 'PROPRIETOR' above 'YEOVIL'. The reverse has the standard closed wreath containing the value 2d. Made of bronze or brass, it is just under 28 mm in diameter and is 1.2 mm thick.
- From the Black Horse Inn, Reckleford, for the value 1½d. On the obverse is 'BLACK' above 'HORSE' above 'INN'. The reverse has just the value 1½d. Made of bronze or brass, it is just under 22 mm in diameter and is 1.7 mm thick.
- From the Albion Inn in Vicarage Street for the value 1½d. On the obverse is 'THE ALBION' above 'VICARAGE STREET' above 'YEOVIL'. The reverse has the standard open wreath containing the value 1½d. Made of brass, it is just under 24 mm in diameter and is 1.4 mm thick.

During this period, 1½d would have bought a couple of pints of local cider or ale, and 2d could buy you a good lunch of tripe and onions.

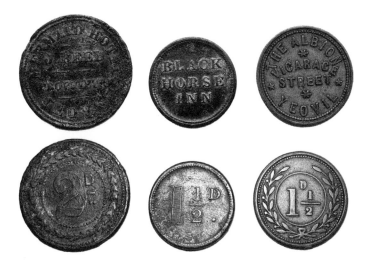

Public house 'checks' were common in late Victorian Yeovil.

Quaker Burial Ground

The Quaker (today known as the Religious Society of Friends) Burial Ground in Preston Lane (today's Preston Road) dates to 1689 when it was carved out of the corner of a field known as Batt's Corner. It contains the remains of 148 Quakers who were buried here between 1689 and 1837.

In 1852, in his report to the General Board of Health concerning, among other items, Yeovil's burial grounds, Thomas Rammell wrote the following concerning burials in the Friends, or Quaker, burial ground in Preston Road:

> The Quakers Burial-Ground is situated about 300 yards beyond the turnpike gate, on the Preston Road, and is therefore quite removed from the town. It is a very old ground, established upwards of a century. It is about one-eighth of an acre in extent, and the interments are few, about 19 having taken place in the last 29 years. It is a dry ground, and lies high.

Surviving headstones in the Friend's burial ground, Preston Road.

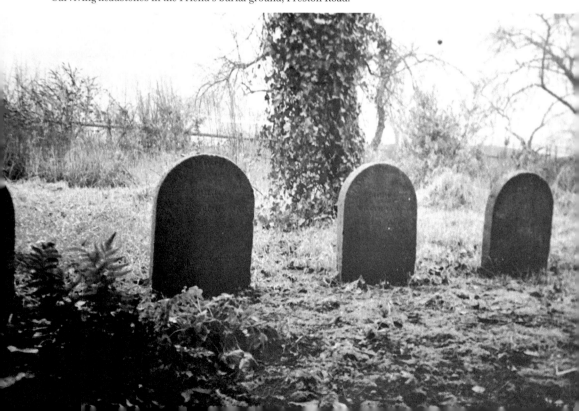

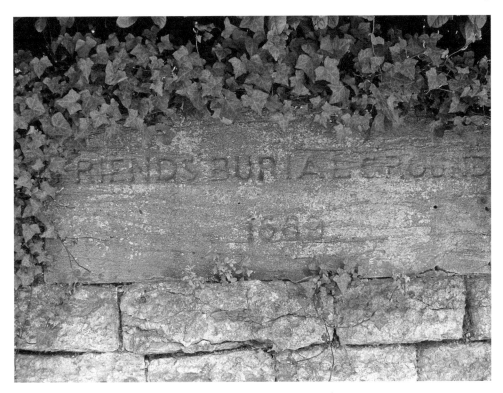

The Preston Road date stone is inscribed 'Friends Burial Ground 1689'.

In fact, Quaker meetings were first held in Yeovil in 1654, fifteen years earlier than the date on the wall of the burial ground. It was, however, privately owned and in his will of 1716 Yeovil glover Samuel Goodford the Elder bequeathed the burial ground to his son William Goodford. The first Quaker meeting house dated from 1690 and was built in Kingston.

On the 1886 Ordnance Survey, the site is shown as 'Friends' Burial Ground (Disused)' although the burial ground remains today, albeit locked. Mounted in its boundary wall facing Preston Road is a date stone that is inscribed 'Friends Burial Ground 1689'.

The Quedam

Quedam Street, the later Vicarage Street, had been a street within the medieval town of Yeovil since Saxon times. In medieval times much of the northern boundary of the Borough was a small stream or brook called the Rackel, or Rackle, which ran along the rear of properties on the northern side of Quedam Street. A thirteenth-century document from the reign of Henry III (r. 1216–72) refers to it as Quedamstreete. The name Vicarage Street, which appears to have happily existed alongside the name Quedam Street for several centuries, was named after the vicarage of St John's Church, which was established there in 1377.

The street itself ran eastwards from Silver Street, opposite St John's Church, before veering south-east and joining Middle Street at Vennell's Cross, now called the Triangle.

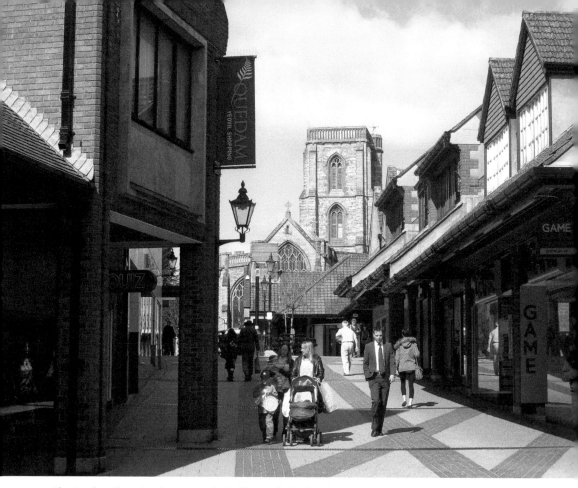

The Quedam Shopping Centre, overlooked by St John's Church.

It has been suggested that the word 'Quedam' was possibly a corruption of the Latin word *quedum,* meaning 'a certain street' or place of an uncertain name. However, a lease dated 4 September 1794, in which carpenter John Rossiter leased a burgage and garden from John King, bookseller, 'in a certain Street there [that is, Yeovil] called Quedam Street', inferring that it was actually the name of the street rather than meaning a place of an uncertain name.

Building the Quedam Shopping Centre during the early 1980s was the largest construction project ever to be undertaken in Yeovil. The architecture was an attempt to bring a 'village' feel to the town centre's shopping experience, in contrast to the quasi-brutalist style of the much-debated Glovers' Walk project of the 1960s. The Quedam swept away Vicarage Street almost completely as well as most of Earle Street, Vincent Street and Vincent Place. The views from Silver Street, Market Street and the Triangle were changed forever.

R

Raymond, Walter

Walter Raymond was born in 1852 in Vicarage Street, the son of glove manufacturer Cuthbert Raymond. Two years after his birth, Walter's mother and sister died of typhoid and Walter was sent to live with his grandparents in Marston Magna. Walter also got typhoid but made a recovery. His grandfather died shortly afterwards and Walter and his grandmother went to live in the Marston schoolhouse with his schoolmistress aunt. His father remarried and Walter returned briefly to Yeovil but was very soon sent to school in Sherborne. Matilda, his stepmother, already had six children but raised Walter as her own.

His father built up his own glove-manufacturing business and Walter joined it around 1875 but was never really interested in gloving. In 1878, Walter met and married Mary Johnston. The 1891 census records Walter and Mary with their eight children, a governess, two nurses, a cook and a housemaid all living in a house in Vicarage Street. Walter, now aged thirty-nine, was listed as a glove manufacturer, although by this time he was completely disillusioned with gloving.

Walter Raymond, poet and author of Somerset rural life stories.

Walter had frequently had articles and poems published in local papers and in 1888 his book *Misterton's Mistake* had also been published locally. In 1892, encouraged by his success with writing, he turned his back on gloving in order to pursue a literary career.

Walter and Mary moved to Preston Plucknett where he could devote himself to country writing. His next published works – all based on Somerset rural life – were *Taken at His Word* and *Gentleman Upcott's Daughter*. The latter, probably his best novel, was the first written under the pseudonym 'Tom Cobbleigh'. In quick succession came *Young Sam and Sabina*, *Tryphena in Love* and *Love and Quiet Life*. The books were very simply written with no convoluted plots or wordy descriptions. Nevertheless, his Arcadian style was well suited to Somerset country life, the chief subject of his writing, and earned him critical acclaim.

Walter died in Southampton in 1931. His ashes were buried with his wife in Yeovil cemetery. His books have been out of print since the 1930s.

Reckleford Cross

Today's Reckleford originally started at the junction with Higher Kingston at the crossroads with Court Ash Terrace and what would become The Avenue in the west. From here it was known as Reckleford Hill as far as Goldcroft, beyond which it was known as Lower Reckleford, later just Reckleford, until it joined with Sherborne Road close to Sun House. Today's Market Street, on the other hand, was earlier known as Reckleford or Rackleford because it had a ford across a stream called the Rackle.

This replica of Reckleford Cross stands in front of the Church of the Holy Ghost.

The area around the junction of Market Street with Reckleford was known as Reckleford Cross because in earlier times a wayside cross had stood there. Watts' map of 1806 shows the cross and is annotated with 'Cross'. None of the 1831 maps variously drawn by Watts, Day or Madeley show the cross, but Bidder's map of 1843 shows it – or perhaps just its remains – as a dot in the middle of the road. It is certainly not shown on the 1858 map of Yeovil or any maps thereafter.

In April 1916 Preb. E. H. Bates Harbin reported in *Somerset & Dorset Notes & Queries* the discovery of a 'much-mutilated head of a cross' reckoned to be possibly of thirteenth-century date. It was discovered during road widening at the junction of Reckleford and Sherborne road near Sun House Farm, some 500 yards away from its probable original location.

The block of Ham Hill stone was 16 inches wide, 14 inches high and 5 inches thick (410 mm x 360 mm x 130 mm). Large pieces had broken off at both the top and the bottom, and the sides were chipped. One face retained the outline of the figure of the Blessed Virgin Mary seated and holding her child in her left arm. The other face originally contained the Crucifixion with the figures of the Virgin and St John on either side, but only the figure of the Virgin survived.

Robin Hood Pageant

Although the legendary folk hero Robin Hood ostensibly has nothing to do with Yeovil, the Elizabethan churchwarden's accounts of the early sixteenth century show a well-established tradition that the Robin Hood story was enacted here as an annual pageant.

The pageant was usually held on Ascension Day, a traditional Church feast day celebrated on a Thursday, the fortieth day after Easter Sunday. Each of the great feast days of the Church was a general holiday, when the dreariness of day-to-day life was relieved by parades, pageants, plays, church ales and sporting events such as archery at the butts, cockfighting, bull-baiting and the like. These events took place at the 'The Kennels', later known as Sheep Fair, being that area of land (now a car park) between North Lane and Court Ash.

It appears from the churchwardens' accounts that the part of Robin Hood, often called Robert Hood, was played by a prominent townsman, as were the other characters. Contemporary accounts show payments for hiring the garments and even a payment to 'John Fletcher for fetherynge Robarte Hoodes Arrowes'. Other expenses invariably included ale for the church bell-ringers.

The chief purpose of the pageant was to raise money for church funds. Income derived from the pageants was a considerable sum each year; for example, £10 in 1540 would be worth around £6,000 at today's value. The monies were collected from the townspeople by the churchwardens in much the same way that Somerset street carnival collectors do today.

Seal of the Borough of Yeovil

Yeovil was officially designated as a borough in 1854. The seal of the borough of Yeovil is from a document dated 1877 and is based on the original fourteenth-century town seal used by the town's lord and his portreeve. The main shield depicts St John the Baptist, standing beneath an arch with trees on either side. He is holding a shield with a representation of the Agnus Dei, the Lamb of God.

The seal is a device for making an impression in wax or other mediums. The purpose was to authenticate documents. The sealing process is essentially that of a mould, with the final image represented on the device for making the impression by a mirror-image design, incised in sunken relief, or intaglio. The seal-making device is also referred to as the seal matrix or die; the imprint it creates is the seal impression.

The seal impression in this photograph measures 3 inches (75 mm) across. Impressed into red candle wax, it was placed on a bright green silk square attached to the vellum (calfskin) document.

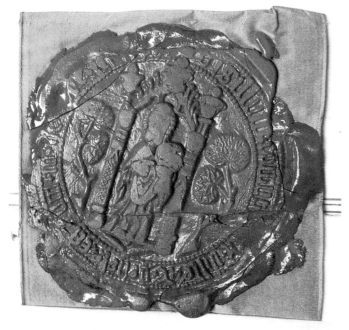

This wax seal of the borough of Yeovil dates to 1877.

Sidney Gardens

Sidney Gardens, a 3-acre triangle of open space in the former field called Ram Park, was presented to the town by Alderman Sidney Watts when he was mayor. The gift of land was to commemorate the 1897 Diamond Jubilee of Queen Victoria, although the gardens were not officially opened until 23 June the following year. The gardens were created at a cost of £760 and Mr Watts graciously named the gardens after himself. However, as he was away representing Yeovil at the jubilee celebrations in London, the ceremony was carried out by his two daughters Ada and Mildred. It was estimated that over 5,000 people witnessed the ceremony as Ada handed the deeds of the land to the deputy mayor, William Cox. The *Western Gazette* reported that she then planted a memorial tree declaring it to be 'well and truly planted in Sidney Gardens and hope it will grow and flourish and thus hand down to future generations the story of the ever-to-be-reminded 22nd day of June 1897, God Save the Queen'.

The fountain, which hasn't seen water for many years, was presented to the town by John Farley on 24 May 1899 to commemorate Queen Victoria's eightieth birthday. It was restored in 1991 but when civic chiefs and private sponsors gathered for the official switching-on ceremony it was discovered that a pump had been stolen and the stem damaged. It has been dry ever since.

A sundial on a stone plinth was installed in the gardens in November 1912 commemorating the gift of the gardens to the town by Sidney Watts. It was almost immediately vandalised and thereafter surrounded by protective railings and a reward of £1 offered for information leading to the arrest of the vandals. The railings were removed for the war effort in 1941 and the sundial and plinth were removed from the gardens in the mid-1990s.

Today the trees have grown and the gardens are a very pleasant, relaxing haven just a short walk from the town centre.

The fountain hasn't seen water for many years, yet Sidney Gardens is a wonderful place to relax.

Skeleton Army

The Yeovil Corps of the Salvation Army was founded in 1882 following the appearance of a poster in the town announcing 'The Salvation Army will open fire in the Cattle Market on Sunday 28th of May 1882 at 10 am. Everybody welcome. Major Davey in command, assisted by Captain Crocker'.

However, there was much disquiet in the town and serious, frequent riots erupted in the streets throughout September and October 1882. A mob of hundreds, branded the 'Skeleton Army', used stones and rotten eggs as ammunition against the Salvation Army and serious scuffles broke out on several occasions, described in great detail by the newspaper reports of the day. In fact, this type of local protest 'riot' was common across the country at this time, not just in Yeovil.

The Skeleton Army was a diffuse group, particularly in southern England, that opposed and disrupted the Salvation Army's marches against alcohol in the late nineteenth century. Clashes between the two groups led to the deaths (albeit not in Yeovil, although blood was shed here on several occasions) of several Salvationists and injuries to many others.

The 'Skeletons' recognised each other by various insignia used to distinguish themselves. Skeletons used banners with skulls and crossbones; sometimes there were two coffins and a statement like 'Blood and Thunder' (mocking the Salvation Army's war cry 'Blood and Fire') or the three B's: 'Beef, Beer and Bacca' – again mocking the Salvation Army's three S's, 'Soup, Soap and Salvation'. Banners also had pictures of monkeys, rats and the Devil.

Several techniques were employed by the Skeletons to disrupt Salvation Army meetings and marches. These included throwing rocks and dead rats, marching while loudly playing musical instruments or shouting, and physically assaulting Salvation Army members at their meetings.

By 1918 the former *Western Gazette* offices were being used as a Salvation Army Temple.

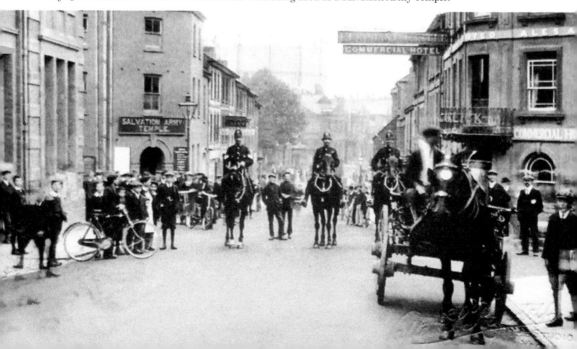

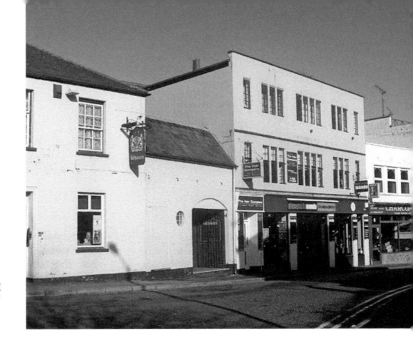

The three-storey building was home to the Soldiers' Rest Room during the Second World War.

Soldiers' Rest Room

During the Second World War, a café in Westminster Street became a soldiers' canteen, known as the Soldiers' Rest Room, run by volunteers. The Soldiers' Rest Rooms were set up across the country, often by Church groups, with the intention of providing food and drinks to servicemen as well as somewhere to relax. They tended to remain open twenty-four hours a day and as one volunteer recalled, 'It did a lot of good for those boys. They were away from home and it was somewhere to go without going to pubs, and a lot of them were very grateful for it.'

There were sandwiches, 1d on bread, or 3 halfpence on teacakes, and rather plain 'fancy' cakes. A small allocation of coupons was sometimes allowed to purchase some chocolate bars for the soldiers to buy, but generally speaking, there was no increase in food allocation. Volunteers sometimes made little foraging parties, going around knocking on doors asking if they had any food to spare; sometimes a few slices of bread, a piece of cheese, a few biscuits. The local people responded well.

The Soldiers' Rest Room stayed open all night, with volunteers turning up to help even though it was not their turn on the rota. Every soldier who came in was fed and given a cup of tea, but never asked for a penny. In the 'quiet' room upstairs there were a few tables, and paper and stamped envelopes were provided for soldiers to write home – once again for free.

St Michael & All Angels' Church

St Michael & All Angels' Church was designed by Yeovil architect J. Nicholson Johnson in a uniform early fifteenth-century style with touches of art nouveau. Largely paid for by the Cole family, it cost in the region of £10,000 (around £2 million at today's value) and opened in 1897 to serve the newly formed Pen Mill parish. The new church was originally known as The Cole Memorial Church of St Michael. The vicarage next door was built at the same time, and both were built in the former field called Goar Knap.

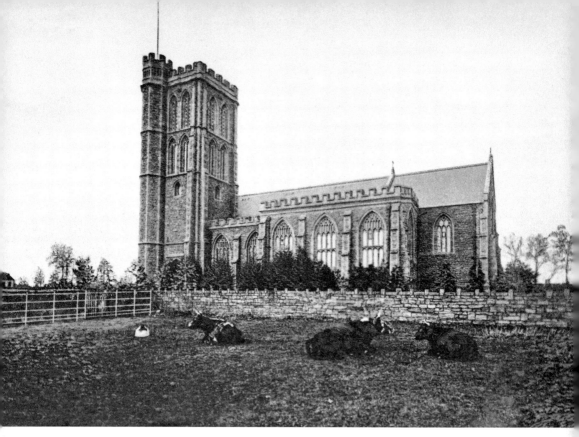

A colourised postcard of around 1902 when St Michael's Church was surrounded by fields.

At the time St Michael & All Angels' Church and vicarage, together with the Pen Mill Board School of 1894, were the only buildings north of New Prospect Place along the track known as Brickyard Lane that ran north from Goar Knap and the Sherborne Road. Brickyard Lane was to take the name of the church, becoming St Michael's Avenue.

St Michael & All Angels' Church is built of squared random coursed Ham stone with ashlar dressings under a Welsh slate roof. It has a short chancel, a five-bay nave and north aisle, a three-bay Lady Chapel on the south side, with a short south aisle, all with fifteenth-century style traceried windows. The tower, at the west end of the south aisle, has offset corner buttresses and is of four stages. It has a pointed arched doorway to the with a rectangular carved panel above.

Originally built with a large number of crocketed pinnacles surmounting the tower and stair turret, a violent storm in October 1896 blew two pinnacles down; one crashed through the church roof and the other nearly struck a man passing by.

The Summer House

Newton Surmaville was in the possession of the Harbin family from the time it was built by Robert Harbin, between 1608 and 1612, until when it was sold in 2007 – for the first time in its history. Part of the original estate included Summerhouse Hill surmounted by the Summer House, also known as the Round House, which overlooks the town of Yeovil and is a well-known Somerset and Dorset landmark.

The Summer House photographed (with a very long telephoto lens) from Pen Hill steps.

Referring to the Summer House, *Country Life* reported

> ...the erection of the building can be safely attributed to Swayne Harbin, who inherited his father's property in 1741. The summer-house, a particularly pleasing example of 'folly' architecture, commands a fine prospect northwards over Yeovil, and on a clear day, one can see Glastonbury Tor far away to the northwest. The summer-house has now been converted into a cottage, but in its heyday, it was apparently used by the Squire of Newton when he was entertaining his friends on fine summer afternoons.

There were originally three of these follies. The other two were at Montacute, built by Mr Phelips, and at Chilton Cantello, built by Mr Goodford. Each was visible from the other and tradition has it that when a flag was flown from one the owners of the others would 'gallop over for a convivial evening'.

The building is octagonal and three storeys high. It is of dressed stone and has its sides alternately curved and straight. It is flanked by wings, one of which contains the staircase. The wings are of coarser masonry than the octagon.

Although derelict in the 1960s, the Summer House has since been restored and is now a private house.

Summerhouse Hill

As any visitor to Yeovil soon learns, the town is very hilly. However, the most spectacular hill is Summerhouse Hill on the immediate southern edge of the town – the summit stands at 353 feet (107.6 metres), making it the highest point in Yeovil. Traces of medieval farming practices still exist today on the lower slopes of Summerhouse Hill in the form of lynchets.

Passing its nine specimen oak trees on its steep flank, the walk to the top is well worth the effort. You are rewarded with spectacular views across the town and to the countryside beyond. On a clear day it is rumoured that you can see the Bristol Channel to the north. More easily visible are the north Dorset Downs to the south, the hills at Montacute to the east, the Exmoor Hills on the horizon to the north-west, the Mendip Hills to the north and the Corton Denham ridge to the northeast.

As the town of Yeovil grew dramatically in the nineteenth century, supplying the town with water became a constant problem. Traditionally the town had relied on numerous wells throughout the town for its water supply, but as the town expanded and its population grew these proved inadequate and summer droughts became a regular feature. In 1897, a huge underground reservoir was constructed on the top of Summerhouse Hill with a capacity of 1 and 0.25 million gallons. In time this proved inadequate and today the town's water comes from Sutton Bingham reservoir.

Summerhouse Hill on the very edge of Yeovil, with the Summerhouse just visible at the top left.

T

Tabernacle Lane

Tabernacle Lane, earlier called Little Lane, is a narrow alley running from the Borough to South Street. The earliest mention of what is now called Tabernacle Lane was in a document dated 1386 in the Woborn Almshouse archives. Another dated 1400 also mentions properties in the lane. In a Woborn Almshouse lease dated 1464 it is referred to as Narwelane (Narrow Lane).

A serious fire occurred in 1802, in which thirteen houses in the alley as well as outbuildings were destroyed. After rebuilding, the lane had four houses. It was later called Hannam's Lane because Josiah Hannam, a senior member of the Society of Friends, had an ironmongery warehouse and a yard there. Hannam also owned a hardware shop on the corner of Tabernacle Lane and the Borough in premises that

This surviving medieval lane has had many names through the centuries.

had formerly been an inn (named the Lyon Inn, then the Eagle Tavern and finally the Falcon Inn). However, Tabernacle Lane has been the most often used name for the alley since the founding of the Tabernacle Meeting House there in 1804.

In the 1841 census, it was listed as Tabernacle Lane. In 1851, it was recorded as Hannam's Lane and in 1861 as Little Lane. The name reverted to Tabernacle Lane from 1871 onwards.

Templeman, Henry 'Temple Bar'

Confectioner Henry Charles John Templeman (b. 1817) – variously known as Henry or Charles and also by the nickname of 'Temple Bar' – was married to Jane Dodge. In the 1841 census Henry, Jane and their two young sons, Henry Jr and William, were living in the house of his widowed mother, Mary, in Belmont – the continuation of Park Street where it joins Hendford. Mary gave her occupation as 'Pauper formerly glover'.

In 1860, Henry was found guilty of being drunk and disorderly (not for the first or the last time) and fined 10 shillings by the magistrates. In fact, there are several newspaper reports from this period when he appeared before the magistrates invariably for the same offence.

By 1861 the family had moved to Grope Lane (today's Wine Street), where Mary was still recorded as the head of the household. Henry, recorded as Charles, and Jane now had a third son, Simeon. Henry/Charles was now working as a 'Newsvender', as was eleven-year-old William. Thirteen-year-old Henry was working as a leather dresser.

In 1863, Jane was charged with receiving 14 lbs of potatoes and four turnips. Found guilty, she was sentenced to fourteen days' hard labour. Not to be outdone, Henry 'Temple Bar' Templeman received fourteen days for being drunk and disorderly in 1865, which according to the *Western Gazette* would 'give him an opportunity of reflecting upon the uselessness of profanity, and the majesty of the law'. The *Gazette* also notes that Henry 'Temple Bar' was fined 1s for being drunk and swearing in the street again in August 1873.

Trade Tokens

Most Yeovil trade tokens were issued by tradesmen following the death of Charles I in 1649, in order to overcome the lack of small change in general circulation and to enable trading activities to proceed. The token was in effect a pledge redeemable in goods, although not usually for currency. These tokens never received official sanction from the government, but were accepted and circulated quite widely. No copper coinage was minted during the Commonwealth and the resulting paucity of small coinage was met by these independently produced and completely unauthorised tokens of brass, latten (a copper alloy similar to brass) or pewter. From 1672, in the reign of Charles II, farthings were minted again, with the consequent demise of trade tokens. The value of a farthing in the 1650s was roughly equivalent to £2 today.

These four examples of Yeovil farthing tokens were all issued by Yeovil tradesmen in the 1650s. All are around 15 mm in diameter and 0.75 mm thick. The first example,

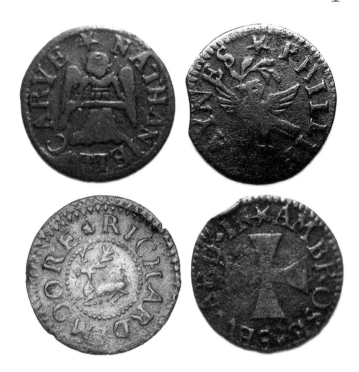

Four Yeovil farthing tokens –
unofficial currency from the
1650s and 1660s.

at the top left, is from the Angel Inn, Hendford, and dated 1652, the earliest recorded
for Yeovil. It depicts an angel in the centre of the obverse together with the licensee's
name, 'NATHANIELL CARYE'.

Next, at the top right, is a token with the name 'PHILLIP HAYNES' around the edge.
In the centre is a dove with an olive branch in its beak. It is dated 1655.

Issued in 1668, the token at the bottom left is inscribed 'RICHARD MOORE' around
the image of a hart or deer. It is almost certainly from the White Hart (an early name
for the Castle Hotel), Middle Street.

Finally, at bottom right, this token has the name 'AMBROSE SEWARD' around a
central cross pattée. Although not dated, it is almost certainly contemporary with the
other three tokens here. In 1647, the quarter sessions recorded that Ambrose Seaward
was a 'Constable of the Borough' and in the monthly Poor Rate Return, it was recorded
that he paid for a property in the Borough and another in Kingston.

Turnstile Lane

The area known today as the Triangle is where Middle Street, South Street,
Vicarage Street, Stars Lane and Fore Street (Lower Middle Street) met and in
earlier times was the easternmost point of the borough of Yeovil. It was originally
called the Triangle because it was a small triangular piece of land containing
buildings, shown on all known maps up to and including the 1886 Ordnance
Survey, that was bounded by Middle Street on the north, South Street to the south
and a small lane, some 12 feet wide but less than 10 feet at its narrowest point,
known as Turnstile Lane.

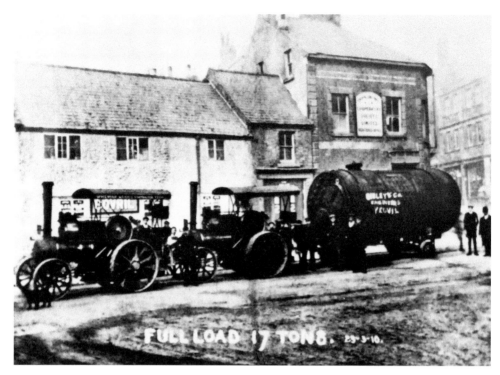

The remaining buildings of Turnstile Lane seen immediately before demolition in 1910.

Turnstile Lane, running between Middle Street and South Street, was so called because of a restriction placed on it to prevent vehicular traffic driving through it. Its western side is marked by the building built for the Co-operative Society in 1910, which now faces east across the open space we call the Triangle today.

For many years in the late nineteenth century it was known as Lollipop Lane because there was a bakery at one end and a grocery store that sold children's sweets, including lollipops, at the other end. Both were owned by a Mr Connock.

To the east of Turnstile Lane, in the open space now known as the Triangle, was a block of cottages in the form of a triangle. Three cottages, a corner house and shop faced Middle Street, three cottages faced Turnstile Lane and two cottages faced South Street. The Middle Street shop included an oven and bakehouse, a flour loft and stables. This triangular block of buildings was demolished around 1900.

U

Union Street

Until the 1830s Grope Lane, now Wine Street, was the only direct access for a cart from High Street, the Borough and Middle Street to South Street – George Court and Tabernacle Lane were too narrow for a cart.

The draper and mercer Peter Daniell of Penn Hill owned a mansion in Middle Street that had been built by his father. This mansion stood where the rear of the WHSmith building stands today. He also owned a large tract of land between Middle Street and South Street and much of the land on the north side of Grope Lane. In the late 1820s he planned and built an extension to Grope Lane that became Union Street. He also built Bond Street to connect Middle Street with South Street and then Peter Street, named after himself, to join Bond Street with Grope Lane/Union Street.

The entrance to Union Street from Middle Street was originally much narrower than today's road width. The southern end of Grope Lane, where it met South Street, was called Wine Street from the 1840s. It remained named as such until at least the late 1870s before becoming known as the southern half of Union Street.

Union Street, flanked by two impressive Victorian buildings, seen from South Street.

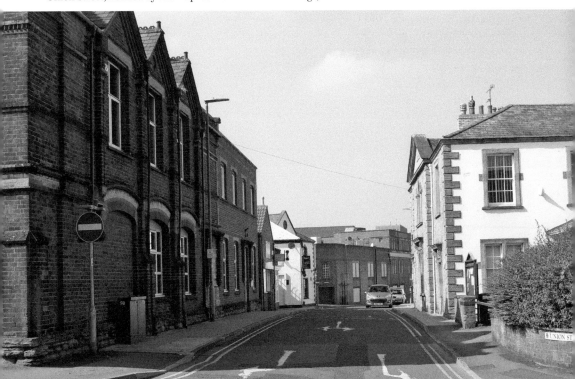

In the nineteenth and early twentieth centuries there was a Union Hall on the east side of Union Street (hence the street's name). Just south of this was a meeting house and on the corner with Wine Street was a fire engine house.

The southern section of Union Street/Wine Street had the small Yeovil Mineral and Aerated Waterworks on the western side (from 1875 until 1900) and from 1888 the Victoria Temperance Hall on the corner with South Street. The eastern side began to get built up from the middle of the nineteenth century with Albany Court and Albany Buildings. In 1849, the Town House was built by the Improvement Commissioners to provide a police station and residence for the superintendent. On the very corner of South Street was the Portreeve's Almshouse, the site of which is now taken by the Town House car park.

Unitarian Chapel

In medieval times the Chantry of the Blessed Virgin Mary Without the Church was supposedly built in Vicarage Street; however, since the chantry was actually attached to the church it is more likely that this was simply a property owned by the chantry that provided some income in the form of rents. The site was later built on and became the Unitarian Church, which was founded in 1704.

In 1722, Dr Milner arrived at the church, where he was to remain for the next twenty-two years. He also conducted a large school in the town. The church declined in the latter years of the eighteenth century but revived somewhat with the rebuilding of the chapel in 1809 – this is the building seen in the photograph.

Thomas Southwood Smith, a young physician who practised medicine in Yeovil, took charge of the Unitarian Chapel in Vicarage Street between 1816 and 1820. He lived in a house in Kingston. Some twenty-five years after Smith had left, John Aldridge would run his Kingston School in the same house, which later became Yeovil County School.

Smith was succeeded by Revd Samuel Fawcett, a radical who chaired a meeting in 1831 at the Mermaid Hotel in support of the abolition of slavery and for

A photograph of around 1900 showing the Unitarian church, in use at this time, to the right.

parliamentary reform. He was local treasurer of the British and Foreign Unitarian Association between 1827 and 1834. He lived at Hollands with his wife, a sister of Edmund Batten. It appears that the Battens were a Nonconformist family and a coffin containing the remains of Edmund's brother Robert Batten, a Yeovil solicitor like his father and two brothers, was excavated in 1982–83 when the chapel was being demolished for the construction of the Quedam Shopping Centre.

Fawcett, in turn, was succeeded by David Hughes. The congregation provided Hughes with the house called Grovecote in Preston Road as a manse.

University Centre

Set in the former council offices in Preston Road, Yeovil College University Centre was specifically created in the 1990s to provide access to high-quality higher education and university provision within Somerset. The centre provides easy access to people within the Somerset, Dorset and surrounding areas, allowing the experience of university life within Somerset itself and what it has to offer. The college works in partnership with Bournemouth, Gloucestershire, Wales Trinity Saint David and West of England universities.

The University Centre offers a wide range of full-and part-time courses including foundation degrees, bachelor's degree, postgraduate programmes and master's degrees. As the needs of industry change the centre's portfolio of programmes is regularly updated to ensure qualifications are what industry needs. Additionally, an extensive range of professional courses – which are at the same level as university qualifications but are specific to certain professions – including marketing, accounting and management. Each course is vocationally orientated, focusing on jobs, career opportunity and progression into industry.

The University Centre has seventeen modern teaching rooms, a 100-seat lecture theatre and rooms for specialist study with an Apple Mac design suite, a photography and media studio, two PC suites and an open-access study area with IT access and a café.

Yeovil College University Centre, housed in former council offices in Preston Road.

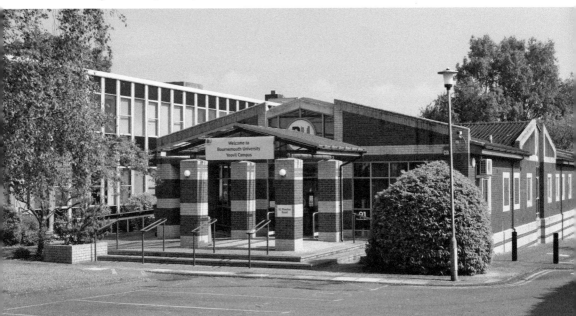

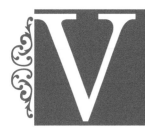

Vincent, Earle, and the Royal Osborne Brewery

It is not really clear when the Royal Osborne Brewery, situated on the southern side of Townsend or Sherborne Road was first established. There had been a brewery just along the road, opposite the Sun House Inn, but it is believed that there was no connection between the two breweries. The first mention of the Royal Osborne Brewery is in a newspaper advertisement placed in the 16 January 1855 edition of the *Western Flying Post* by Timothy Huffam in which he states he has 'commenced brewing'.

Huffam later claimed he brewed 'By Appointment to Her Majesty' and used a royal cypher in his advertisements. This is when the brewery's 'Royal' designation began and 'Osborne' was a reference to Queen Victoria's recently completed Osborne House in Cowes, where Huffam had lived immediately before moving to Yeovil. In February 1863, Timothy Huffam sold the Royal Osborne Steam Brewery to twenty-five-year-old Earle Vincent.

Earle Vincent was born in Lymington, Hampshire, in 1838. He was the son of brewer Earle Vincent and his wife Henrietta. By 1851 Earle Vincent Jr was a boarder at a private school in Bishops Waltham, Hampshire, and by 1861 he was living in New Windsor, Berkshire, with his two sisters Henrietta and Flora. He gave his occupation as brewer's clerk. He worked at the Victoria Brewery, Windsor.

Earle Vincent's advertisement in the 1878 edition of Whitby's *Yeovil Almanack Advertiser*.

In the 1871 census Earle Vincent was living at Osborne House, Sherborne Road, next door to the Osborne brewery. He was listed in the census as a thirty-three-year-old widower with his two daughters, his sister Augusta, a cook and a housemaid. Earle described his occupation as a brewer. In the 1880s Earle Vincent greatly increased the size of the brewery and also started an aerated water works behind the brewery.

Earle Vincent died in the summer of 1893 aged fifty-five. Following his death, his estate was sold. It included the Royal Osborne Brewery and four freehold public houses: the Elephant and Castle Hotel, the South Western Inn, the Butchers Arms Inn and the Foresters Inn at East Coker. There were also several leasehold public houses in Yeovil, including the George Hotel, the Castle Hotel, the Albion Inn, the Black Horse Inn, the London Inn, the King's Arms, the Victoria Inn and the Rock Inn at Stoford. Also Osborne House, Osborne Villa and substantial land holdings as far as Newton Road, which would eventually house the *Western Gazette* building and Aplin & Barrett's factory formed a part of his estate. The estate sold for a total of £9,865 (around £7 million at today's value) and the brewery, together with its tied houses, was bought by Jonathan Drew Knight, brewer of Shepton Mallet.

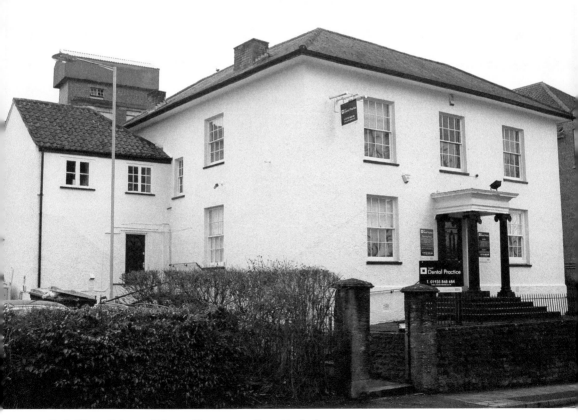

Earle Vincent's home, Osborne House, was adjacent to the brewery.

Vita-Ray Laundry

The founding of the new Vita-Ray Laundry Co. Ltd was announced in the 16 April 1930 edition of the *Western Gazette*, with the laundry opening on 1 September that year. The Vita-Ray Laundry was sited on the lower slopes of Wyndham Hill, adjacent to the Sherborne Road and close to the junction with Lyde Road. The laundry advertised itself as follows:

> This New Laundry is entirely up-to-date and is beautifully situated in Wyndham Fields, with two acres of drying grounds away from smoke and grime. Hygienic Methods. Beautiful Finish. Retention of Colour. The highest standard of Efficiency generally.
>
> A special collar service will be instituted whereby worn collars will be replaced free of charge. Free collection boxes will be erected in convenient parts of the town in which Collars and Small Parcels can be deposited. Collections daily, and articles left in the boxes on Mondays, Tuesdays and Wednesdays will be returned the same week.

There is little information today concerning the laundry, although it was listed in Kelly's Directory of 1935. It was also listed in Edwin Snell's Directory of 1954 and advertisements were placed in the 1967 Yeovil Guide as well as the local press. By 1978, the laundry had closed. The site is now housing.

The Vita-Ray Laundry was the first building to be seen when approaching from Sherborne.

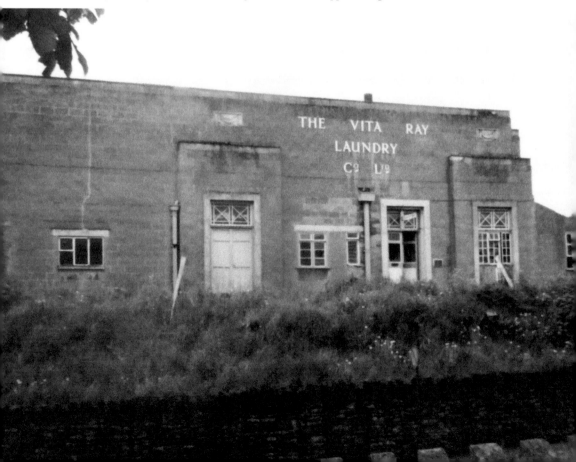

W

War Memorial

A memorial to honour Yeovil's war dead was first proposed at a meeting of the borough council in July 1917 by Mayor Edmund Damon. After much debate over the style of the memorial, its location and so forth, the final memorial was erected in the Borough.

The 29-foot-high memorial was designed by Charles Wilfred Childs and sculpted in Ham stone by Messrs Appleby and Childs at a total cost of £1,250 (around £52,000 in today's value). The style of the memorial was based on the 'Eleanor' crosses erected by Edward I in memory of his wife, Eleanor of Castile, to mark the nightly resting places along the route taken when her body was transported to London in 1290. The original twelve crosses were lavishly decorated stone monuments, of which three survive intact – at Waltham Cross, Geddington and Hardingstone.

The memorial was unveiled by Col Frank Davidson Urwick DSO, president of the Yeovil branch of the British Legion, at a ceremony that took place at 6 p.m. on Thursday 14 July 1921. The *Western Gazette* reported:

> The Yeovil Territorial Company marched in first and took up a position, and they were soon followed by a large contingent of ex-servicemen, headed by the Town Band, who marched in from Middle Street. These veterans, many of who were wearing their medals, kept the ground - a hollow square before the flag-covered cross – and with the police, did much towards preserving the quietude and order before the service. Then came a pathetic little procession into the square, a large party of children, many of them tiny tots, carrying posies of flowers, which they were to place later on the base of the Monument on which were engraved the names of their fathers. Just after the town clock struck the hour the final procession moved through the crowd. Headed by the clergy and ministers of all denominations it included the Mayor and Aldermen and Councillors of Yeovil Corporation. 'The hymn 'Nearer My God to Thee' was sung and the Mayor, Alderman W. R. E. Mitchelmore, addressed the crowd He said that the memorial was a token of love, respect and gratitude for the sacrifice made by those whose names were inscribed upon it and would be a shrine here in Yeovil for the men whose graves were scattered far and wide. At the call of the Mayor, Lieutenant Colonel F. D. Urwick, DSO, who had seen distinguished service with the Somerset Light Infantry in the Middle East, pulled a cord and the flags fell away. The Vicar of Yeovil then dedicated the memorial, a hymn and the National Anthem concluded the ceremony.

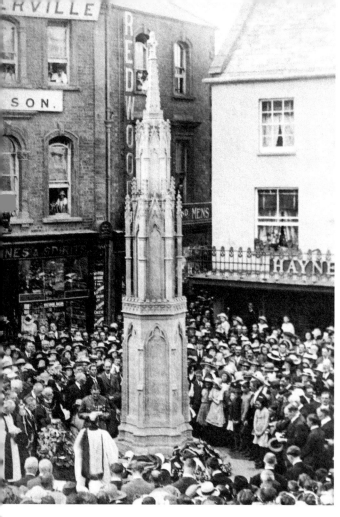

Left: The dedication service for the new memorial took place on Thursday 14 July 1921.

Below: A colourised 1959 postcard – when it was still possible to drive around the memorial.

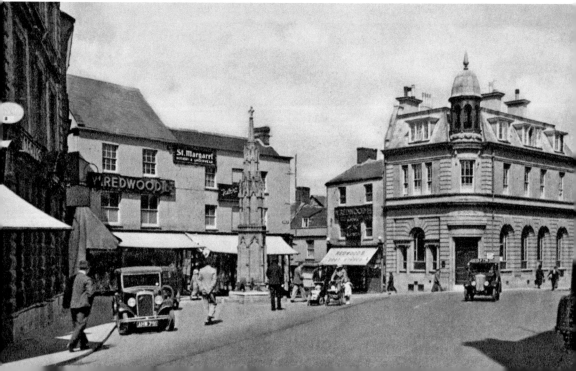

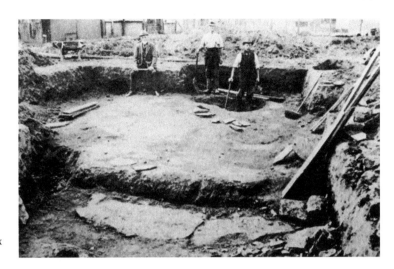

Alderman
Mitchelmore, seated,
at the excavation of
the Westland complex
in 1925.

Westland Roman Complex

In 1916, a hoard of Roman coins was discovered as workmen dug a ditch for a new drain to the south of Westland Road. In 1925 the borough council purchased the land for new housing and Alderman (later Mayor) William R. E. Mitchelmore undertook a preliminary excavation that year, his work revealing extensive foundations. This was followed up in 1927–28 by archaeologist and historian C. A. Ralegh Radford. Initially thought to be a Roman villa, it is now thought that a more comprehensive and extensive Roman complex was sited here that may even have been a Roman town.

A mosaic pavement was lifted from the site and installed in the old museum in the municipal offices in King George Street. It was removed in 1987 to Brympton House but has now been moved again to the Community Heritage Access Centre. A report by English Heritage noted:

> Other remains nearby, in an area bounded on the east and west by Seaton Road and Horsey Lane and on the west by the Roman road probably represent a few outlying dwellings of the poorer class. The Roman site at Westland has been considered generally as a villa, but the evidence from excavation shows that it may be a small town, with a street grid, and extending possibly over 40 acres. The buildings examined in 1928 may be individual houses rather than a unitary villa.

Wild West Visits Yeovil

In the weeks leading up to Saturday 24 July 1903 a large number of colourful posters were put up throughout Yeovil advertising the forthcoming visit of Buffalo Bill's Wild West Show during its two-year tour of Britain and Europe.

When Buffalo Billy Cody came on the first of his three visits to the United Kingdom in April 1887, the furore he created was unprecedented. Thousands lined the streets when the exhibition made its way to Earl's Court, and on its opening night 28,000 people

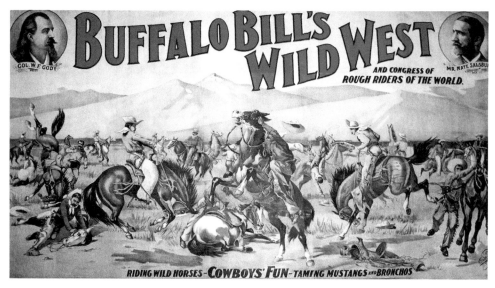

In 1903, many posters such as this heralded the arrival of Buffalo Bill's Wild West show to Yeovil.

were there to see the splendour that was Colonel Cody's Wild West. Buffalo Bill would return again in 1891–92 and finally from 1902 to 1904. Scenes from his Wild West included reenactments of frontier experiences, including battles between Indians and the cavalry. Indian men, women and children posed near tepees in front of painted backgrounds of mountains and other outdoor scenes.

To say that the show was large is something of an understatement. When it visited Yeovil and detrained at Hendford station in the early hours of Saturday 24 July 1903, it included over 700 people and 400 horses. The showground was set up in a large field called Yarn Barton to the immediate west of today's Horsey Lane and the immediate north of Hendford Station. A canvassed area surrounded the large open space in which the show took place, measuring 325 feet by 500 feet (100 metres × 150 metres), and seating was provided for 15,000 people. It was estimated that some 9,000 people came from far and wide to watch the afternoon performance and 15,000 more enjoyed the evening performance, which was illuminated by electric lights.

Wyndham Hill

Wyndham Hill was earlier known as Kingston Penn, Windmill Hill and Victoria Hill. It only got its present name in the 1890s and was named as such for the first time in the 1891 census.

Wyndham Hill, now bordered on three sides by concrete, development and car parks, lies on the immediate southern edge of the town with the River Yeo to its south. It always offers a quiet place to relax as more people tend to visit nearby Summerhouse Hill with its spectacular views. Crowned by its four lime trees, the summit of the hill is recognisable from many parts of Yeovil. Originally twenty-five trees – of various varieties – were planted to celebrate Queen Victoria's Silver Jubilee in 1862.

During the Second World War, Wyndham Hill was the location of a barrage balloon site. This was the easternmost site of a barrage cover that stretched to Brympton

Wyndham Hill viewed from Newton Road.

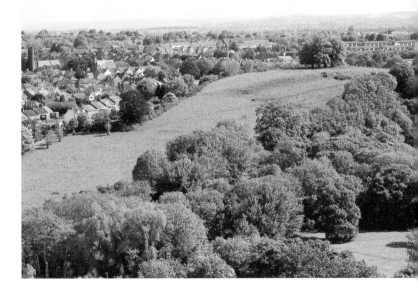

Wyndham Hill, on the very edge of the town, viewed from Summerhouse Hill.

d'Evercy and was designed to protect Westland's airfield and factory from aerial attack. In 2013 the *Western Gazette* reported:

Human remains dating back 4,000 years have been found by a dog walker in Yeovil. A human jawbone and shinbone were recently unearthed in a field on the crest of Wyndham Hill. It is thought the bones date back to the Bronze Age – which stems back as far as 2,000 BC. A man stumbled across the decayed remains while walking his dog. Bones were found poking out of the sandy soil after a herd of cows had churned up the ground. The remains were found shortly after 1.30 p.m. on Tuesday, May 7. Three hours later it was confirmed that the bones were human. A police spokesman later said 'Having since had the bones examined further it has been concluded that they are fitting to the Bronze Age, and as such, there is no further police investigation'.

X

X-Ray Fund

It was not until 1895 that X-rays were discovered by German physicist Wilhelm Röntgen. The first use of X-rays under clinical conditions was by John Hall-Edwards in Birmingham on 11 January 1896, when he radiographed a needle stuck in the hand of a colleague. Three weeks later Hall-Edwards was also the first to use X-rays in a surgical operation.

The many applications of X-rays immediately generated enormous interest and they were used for therapy from the earliest times. Skin lesions were easily treated and techniques evolved to treat deeper abnormalities. Most of the early X-ray work was performed by doctors in larger hospitals and the departments were often combined with electro-therapeutic departments. However, from around 1903 lay X-ray operators were appointed as assistants.

In 1916, the Yeovil X-ray Fund was begun in order to purchase X-ray equipment for Yeovil Hospital at Fiveways. By December 1916 the amount raised had reached £122. An additional fund, the Thousand-Shilling Fund, was begun on 1 December 1916 for the collection of smaller sums. Townspeople were asked to subscribe to the fund by adding to the collection cards in circulation in the town. Within a week an additional £6 6s 4d had been raised. The funds continued into 1917, when an X-ray machine was finally purchased.

However, its use was expensive and the *Western Chronicle*, in its edition of 1 February 1918, reported that the total sum of £17 19s had been received from private patients for the use of the X-ray installation since it had been in use.

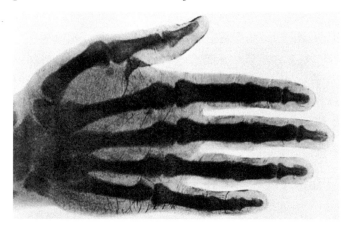

This very early X-ray photograph is very primitive when compared to today's images.

Y

Yeovil at Domesday

After the conquest of 1066, William I gave the manors of Yeovil to Robert, Count of Mortain and William, Count of Eu. The manor that was to become Kingston Manor was held by tenant-in-chief Robert, Count of Mortain and half-brother to William the Conqueror. Robert also held Houndstone. William, Count of Eu was tenant-in-chief to that part of Yeovil and part of Preston Plucknett that would become Hendford Manor.

To this were added twenty-two freeholdings (later known as 'The Tenement'), which would later become the medieval manorial borough under the Maltravers family, lords of Hendford. These twenty-two messuages indicate that a small Saxon 'vill' was within the nucleus of the foundling borough of Yeovil. In Saxon terms, a vill was a small collection of houses, in other words, a village.

Ansger de Montagud held that part of Preston Plucknett, later known as Preston Bermondsey, and Lyde was held by tenant-in-chief Roger Arundel.

The Domesday Book of 1086 records Ivle/Givele, Prestetone, Hundestone and Eslide in several entries. The total population (not including the separate entries for Preston, Houndstone and Lyde) was in excess of fifty households, which was quite large at the time. The total tax assessment of eight geld units was very large and shows Yeovil to have been quite profitable for the lords.

Yeovil had a mill, valued at 5s and the livestock comprised eight cattle, ten pigs and 117 sheep.

The first of three extracts from the Domesday Book referring to Yeovil – here called 'Ivle'.

The twin mortuary chapels at Yeovil Cemetery.

Yeovil Cemetery

The legislation, having regard to the sanitary condition of the people, decreed that after certain periods some churches and churchyards should be closed against any further interments. In 1858, the town council were authorised to expend a sum not exceeding £4,000 (something in excess of £4 million at today's value) for the purchase of land for a new cemetery for the town and providing chapels and a lodge. The land purchased was 5 acres in total – four to be used immediately and a fifth to be held in reserve.

The cemetery was extended northwards in 1928 by purchasing a further field, and another field was purchased in 1939.

The cemetery was consecrated in September 1860. Of the twin mortuary chapels, each accommodating some sixty persons, the eastern chapel was consecrated for the use of Church of England use while the western mortuary chapel remained unconsecrated for use by Nonconformists. The chapels of the cemetery are in the Lombardic style of architecture and each consist of a nave and an apse on the southern side, with entrance and vestibules on the north and an open porch on the west of the consecrated and east of the unconsecrated building. The stone employed is partly from Ham Hill and partly from the Pillsbury quarries, near Langport. The architect was Mr R. H. Shout of London and Yeovil.

The twin mortuary chapels, the lodge, cemetery gates, gate piers and boundary walls are all Grade II-listed buildings.

Yeo Leisure Park

Lying on the edge of the town, at the foot of Summerhouse Hill, Yeo Leisure Park was the last large development in Yeovil of the twentieth century, finally being completed in 2002. It was built on the 700-space Old Town Station car park. The car park, in turn, having been built on the site of Yeovil Town railway station.

Yeovil Town station was a joint station, having originally been built by the London & South Western Railway (L&SWR) and the Great Western Railway (GWR). The station was famous at one time for having two stationmasters as both the railway companies operated through it.

The buildings of Yeo Leisure Park are dominated by Summerhouse Hill.

The dining outlets of Yeo Leisure Park.

The stylish new Yeo Leisure Park complex boasts a fitness centre complete with 25-metre swimming pool, gym, fitness studios and café. The complex also has a ten-screen cinema, two restaurants and other retail outlets. A recently refurbished bowling centre contains eighteen state-of-the-art bowling lanes, pool tables, the latest games, amusements and big-screen TVs, as well as a bar and restaurant.

Yeovil Friendly Societies

A friendly society, sometimes referred to as a mutual society or benevolent society, was a mutual association for the purposes of providing insurance, pensions, savings or cooperative banking for its members. It was an organisation or society composed of a body of people who joined together for a common financial or social purpose. Before the introduction of the welfare state and modern insurance, friendly societies provided financial and social services to their members, often according to religious,

Only two examples are known of this Yeovil Guardian Friendly Society medallion.

political or trade affiliations. Some societies concentrated their efforts in a financial way, like an early savings bank, while others may have offered members financial support, goods and services when needed – such as during sickness, etc., or having their funeral paid for. Additionally, most of Yeovil's friendly societies had an important social and ceremonial aspect.

Between the late eighteenth and early twentieth centuries, each society would hold an annual 'Feast Day' or 'Walking Day', usually in spring. The members would parade through the town, with the officers and many of the members carrying poles or staves, often painted and between 4 and 8 feet (1.2 to 2.4 meters) in length. Some poles, also known as rods, wands or club sticks, were headed by garlands of flowers, although many West Country poles were headed by a brass finial with a distinctive shape and decorated with ribbons.

At one time Yeovil boasted some twenty or so friendly societies. One of the earliest Yeovil friendly societies to be established was the Yeovil Old True Blue Benefit Society in 1782. It was often known as the Old Pall Club because it met in the Pall Tavern in Silver Street and appears to have been constituted for a set period, usually seven years, and at the expiration of the period immediately reconstituted for a further period, etc.

Yeovil Town Station

Yeovil Town station opened in 1861 and was a joint station built by the London & South Western Railway and the Great Western Railway. Hendford, Yeovil's first railway station, was then used for goods only.

In the meantime, the line from Salisbury to Yeovil was being built by the Salisbury & Yeovil Railway and another from Yeovil to Exeter by the L&SWR. The Salisbury–Yeovil railway opened on 1 June 1860 and Yeovil–Exeter railway opened on 19 July 1860, with spurs linking both Yeovil Town and Pen Mill stations with Yeovil Junction station.

The 'Beeching Cuts' refers to the drastic restructuring of the British railway system outlined in two reports, *The Reshaping of British Railways* (1963) and *The Development of the Major Railway Trunk Routes* (1965), written by Dr Richard Beeching and published by the British Railways Board. The first report identified 2,363 stations (55 per cent) and 30 per cent or 5,000 miles (8,000 km) of railway line for closure. The second report highlighted a small number of major routes for significant investment. This was at a time when the railway network had fierce competition from road transport.

The majority of stations and lines were closed as planned and Beeching's name is, even today, associated with the mass closure of railways. First of Yeovil's stations to go was Hendford Halt, which was closed on 15 June 1964, along with the line to Taunton. Yeovil Town station closed to passenger traffic on 3 October 1966, although freight and parcels traffic continued to use the station until 9 October 1967 when these services were also withdrawn. Long-distance trains from Pen Mill had ceased in September 1961, leaving only Yeovil Junction with a service to London. The service between Yeovil Junction and Pen Mill was also withdrawn from 5 May 1968.

Today the site of Yeovil Town station is covered by the Yeo Leisure Centre and its car park, the only remnant being the original foundation stone of the station, which is now set into the wall of a raised flower bed.

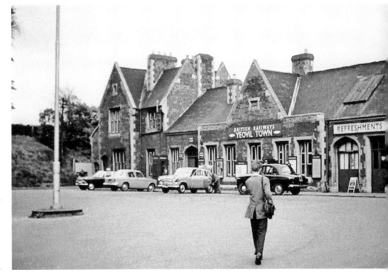

Right: Yeovil Town railway station was famous at one time for having two stationmasters.

Below: A 1905 postcard showing Yeovil Town station filling the lower-right quadrant.

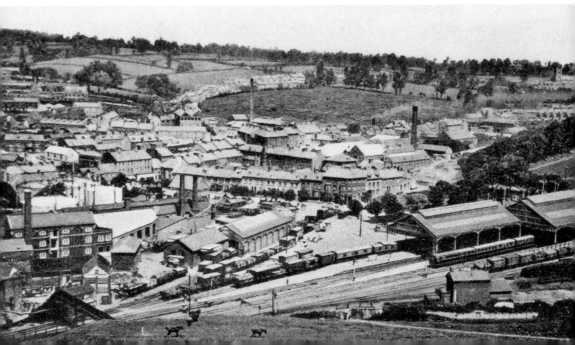

Zeppelins over Yeovil

Many older Yeovilians remember a Zeppelin flying over Yeovil in 1939, but few knew what it was doing overhead. According to the *Western Gazette* this was not the first occasion a Zeppelin visited Yeovil:

> There, over the rooftops, floating through a clear blue sky at about 1,000ft was a long, silver, cigar-shaped object – the Graf Zeppelin. The airship changed direction and headed for the Westland Aircraft premises, where it hovered for a good quarter of an hour. The crew of the airship busied themselves taking photographs – a matter that aroused curiosity rather than alarm. The date was 3 July 1932, and none of the onlookers dreamed that the Germans were gathering information about English military targets in preparation for war.

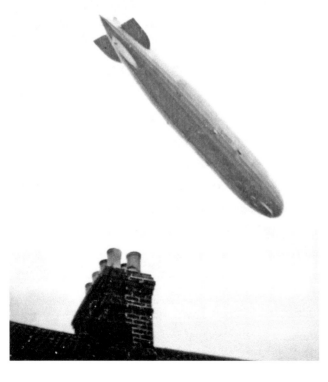

The Zeppelin that flew over Yeovil (Rosebery Avenue) in 1939.

Lieutenant Commander Cyril Topliss RN, MBE, DSM of Summerleaze Park flew many reconnaissance missions over Germany as the cameraman.

Aerial reconnaissance was used by both sides in the period leading up to and during the Second World War for a military or strategic purpose, and was conducted using reconnaissance aircraft on the British part and dirigibles as well as aircraft on the German part. The role fulfilled a variety of requirements, including the collection of imagery intelligence, observation of enemy manoeuvres and artillery spotting.

Again, both Britain and Germany produced aerial surveys of key bombing targets. In 1928, the RAF developed an electric heating system for the aerial camera. This allowed reconnaissance aircraft to take pictures from very high altitudes without the camera parts freezing. Germany, on the other hand, while using reconnaissance aircraft, made much use of dirigibles, otherwise known as airships or Zeppelins, which gave a steady base for the camera.

Post-war studies have shown that the approaches to aerial photography of the Germans and the British were quite different. The British would fly repetitive photographic missions over the same areas over a period of time and compare the results in order to build a cumulative picture of developments – for instance before and after a bombing raid. The Germans, on the other hand, had made such a systematic, detailed and complete aerial photographic reconnaissance of the British Isles early on in the war that they often never revisited some parts for years, if at all.

Acknowledgements

Many thanks to Mike Monk for proofreading not only this book but also my 2,100-plus-page website (www.yeovilhistory.info), which details in much greater depth every subject in this book. The modern photographs in this book are by the author and the old photographs are mostly from the author's collection of old postcards and photographs. The author would like to thank Colin Haine, Jack Sweet and Stella Trent for permission to use copyright material in this book. Every attempt has been made to seek permission for copyright material used in this book; however, if I have inadvertently used copyright material without permission/acknowledgement I apologise and will make the necessary correction at the first opportunity.

—

About the Author

Local historian Bob Osborn moved from north London to Yeovil, Somerset, in 1973. He has written a number of books on an eclectic range of subjects, including local history titles *Secret Yeovil, Yeovil in 50 Buildings, Now That's What I Call Yeovil* and *Yeovil From Old Photographs.* After a career in architecture, admin management, web design and management and, latterly, as a learning centre manager and Yeovil College lecturer teaching IT, he is now retired. Bob now works on researching and compiling his website 'The A-to-Z of Yeovil's History'. Bob has four grown-up children and lives in Yeovil with his wife Carolyn and Alice the cat.